cincinnati 5

CINCINNATI
FIVE

By Emily Moores

Createspace

TABLE OF CONTENTS

Acknowledgments ... 1

Introduction .. 2

The Panel .. 5

Mark Patsfall ... 7

Michael Stillion ... 15

Terence Hammonds ... 23

Pam Kravetz .. 31

Future Retrieval .. 39

cincinnati FIVE

Big box retail, pre-fab architecture and chain restaurants often iron smooth the nuanced fabric of our cities. Faced with this civic sameness, art helps define community. By highlighting individual artists, we illuminate the unique spirit of our city. This book is a celebration of five artists whose work has built community in the city of Cincinnati.

The selection process for the Cincinnati Five included a panel of three judges. From their thirty initial nominations, the judges selected five artists. There was no set application process. Instead, selection criteria heavily emphasized community engagement. Those chosen were required to have a serious art practice with a minimum of five years exhibition experience. Notoriety and name recognition held zero sway; this project's sole focus is illuminating serious artists integral to the spirit of Cincinnati art.

Our artists engage with their community in two ways: by owning a gallery/non-profit, or a commitment to local exhibitions. The included artists who exhibit nationally or internationally treat Cincinnati galleries and museums with the same respect as those in Paris or New York. The Cincinnati Five celebrates those actively engaging Cincinnati, heralding their work and civic contributions.

This project was a massive undertaking. There aren't the words or space on this page to truly express gratitude to the many people who helped form the Cincinnati Five.

Thank you to Steven Matijcio, Calcagno Cullen, Maria Seda-Reeder, Dan Murphy, Sarah Brinker-Good, Keith Good, Lisa Ottum, Elizabeth Tussey and Daniel Beach.

Emily Moores

INTRODUCTION

What connects the work of artists who operate in disparate disciplines, yet share the same geographic location? One could argue of course, that issues of access (invaluable yet pragmatic needs like real estate, employment opportunities, etc.) are an overwhelming factor. Surely having world-class art/educational institutions around town might also endow artists with advantageous proximity to research tools and innovations in media. But the comparatively indefinable yet equally influential quality that unites the work of artists working within this specific locale, is the synergistic climate that evolves around those who seek create a discourse around art in Cincinnati.

Terence Hammonds, Pam Kravetz, Mark Patsfall, Michael Stillion, and the duo of Katie Parker & Guy Michael Davis (who work together as Future Retrieval), are all doers. They may have heard 'no' in the past, but they have learned to trust in their own creative vision, and are capable of galvanizing groups of likeminded individuals to get things done.

Longstanding, well-respected galleries in town like Carl Solway, Miller Gallery, and the recently shuttered semantics, (which operated on a wholly-volunteer basis for nearly 22 years) demonstrate a diversity of work shown in Cincinnati, as well as the broad range of interests of local art-going audiences.

In addition to the established museums and successful commercial galleries in town, Cincinnati has a long and rich history of artist-run spaces that are perhaps the unsung boosters of this town's often avant-garde, frequently ephemeral, and sometimes fugitive contemporary art scene. Artists show their art as readily in living rooms as they might a gallery, and supportive crowds come out for many one-off events, engaging with the work and emboldening artists for their next big show.

Apropos of a city in which people are still able to eek out a respectable living as artists—a rarity these days, it seems—several of those featured in *Cincinnati Five* are not born-and-bred Cincinnatians. They came here to pursue their passions in a place abundant with resources; yet still fighting to overcome a somewhat tarnished reputation as adversarial to artistic freedom of expression.

Twenty-five years after this city was the site of the first criminal trial of an art museum for creative content, artists working in the Queen City have shown themselves still willing and capable of challenging audiences. And area viewers who regularly attend exhibitions and events continue to trust in art to speak to universal and personal truths.

So it remains that those intimate connections we make—as artists, viewers, curators, educators or otherwise—are what make art meaningful. When viewers are engaged, artists and audiences alike experience meaning in new ways. The artists featured in *Cincinnati Five* have demonstrated careers that value the community in which they foster their work. And there is perhaps no better barometer of a healthy local art scene than that!

<div style="text-align:right">--maria seda-reeder</div>

the panel

Steven Matijcio is the curator of the Contemporary Arts Center in Cincinnati. Prior to this he served as Curator of Contemporary Art at the Southeastern Center for Contemporary Art (SECCA) in Winston-Salem, NC from 2008-2013. Matijcio is a graduate of the Center for Curatorial Studies at Bard College and has held positions in a number of galleries and museums including the Plug In Institute of Contemporary Art, the Power Plant Contemporary Art Gallery, the Art Gallery of Ontario, and the National Gallery of Canada. Matijcio was honored in 2010 with a prestigious Tremaine Exhibition Award for the project paperless. *Photo courtesy of Steven Matijcio.*

Calcagno Cullen is a multimedia artist, arts educator, and curator. She is the founder and Executive Director of Wave Pool Arts Center, a gallery, studio space, and socially-engaged artist residency program in Cincinnati, Ohio. Cullen has shown her work widely throughout the US and internationally. She has had solo shows at Market Street Gallery, Million Fishes in San Francisco, and Semantics in Cincinnati. She has been an artist in residence at Kala Art Institute in Berkeley, CA, Lo Studio di Nipoti in Calabria, Italy, and the Children's Creativity Museum (Zeum) in San Francisco, CA. *Photo courtesy of Calcagno Cullen.*

Maria Seda-Reeder is an adjunct instructor at the University of Cincinnati's College of Design, Art, Architecture & Planning; a founding member of Near*By curatorial collective; and a freelance writer for publications as varied as alternative weekly papers, quarterly trade-specific art journals, and institutional members magazines. Seda-Reeder holds an MA in Art History, certificate in Museum Studies, and has been working with and on behalf of independent artist-run spaces, as well as traditional galleries and museums in Cincinnati for nearly 15 years. She actively pursues a multi-faceted career that allows her to dissect, write about, and seek critical perspectives on visual culture and our role as consumers and co-creators in it. *Photo courtesy of Scott Beseler with artwork by Britni Bicknaver.*

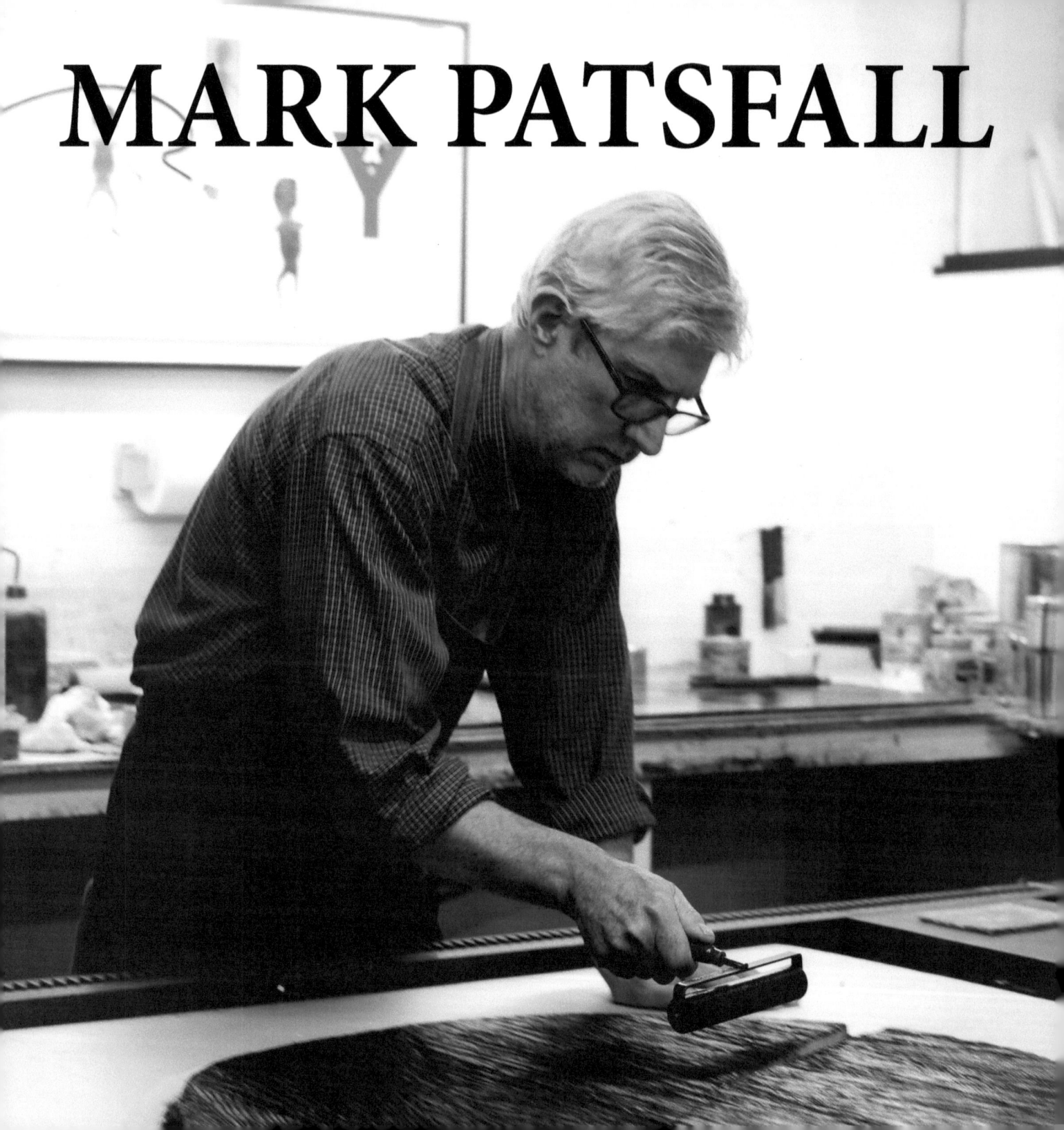

MARK PATSFALL

Growing up between Milwaukee, Cincinnati and Boston, Mark Patsfall remembers choosing trouble over paying attention. This mischievous spirit led to his first experience with printmaking. The father of Patsfall's high school friend was an artist, and when he was out of town, the young man and his friend would sneak into his studio to create dry point etchings. This early experience fostered Mark's life-long love of printmaking. To Patsfall, printmaking is democratic: one plate can produce multiple prints, allowing unique works to reach broad audiences at affordable prices.

Mark studied at Nathaniel Hawthorne College for a year and then Massachusetts College of Art and Design, and served in the army during Vietnam. At the request of his mother, he moved back to Cincinnati in 1974 and applied to the College of Design, Architecture, Art and Planning at the University of Cincinnati (UC). Though not accepted into the School of Art's BFA program, Mark took individual classes at UC. Through the GI Bill and tuition reimbursements earned working as a UC campus security guard for the EPA, the resourceful vet managed to cover all his tuition and expenses.

Eventually, Patsfall earned enough credits to complete his BFA in Printmaking. Determined, he continued his studies and earned an MFA in Printmaking. After graduation, he rehabbed houses in his Northside neighborhood, making prints in his basement. Along with his own artwork, Mark made prints for local, national, and international artists.

Mark's determination fueled him through adversity. He bought a press of his own and turned his garage into a print studio. Success saw him move shop to St. Bernard, only to lose his lease a few years later. As a result, Mark moved all but his etching press into storage and returned to his garage. In 1983, gallery owner Carl Solway asked if Mark would make a suite of etchings with world-renowned Korean artist Nam June Paik. The result was a 20-year collaboration between himself, Paik, and the Solway Gallery.

In 1986, Mark made a down payment on what is now the Clay Street Press in the Over-the-Rhine neighborhood of Cincinnati. Originally named Mark Patsfall Graphics, the printmaker opened the space as a studio for community artists who were also very active during this time such as Jay Bolotin, Tim McMichael, and Terence Hammonds. At first, Clay Street's front room housed a workspace. But in 2000, Patsfall sold a press to create space for additional work tables in the shop area and to transform the lower level into a gallery.

Mark's dedication to printmaking in Cincinnati is no clearer than in his decennial portfolios. Every 10 years since the 1980's, Mark publishes and prints portfolios of prints from a variety of local artists. Mark selects the participating printmakers and covers the cost of their supplies. Each boxed portfolio of prints are a mixture of etchings, lithographs, relief prints and silk screen. They vary from multicolor to black and white. Participating artists receive a full portfolio and all of his/her proofs. Mark gets the remaining portfolios, and sells them, usually for a loss.

Patsfall's hard-nosed perseverance seems the very epitome of Cincinnati artistic prowess. Continuing his studies even after being initially denied admission into a BFA program, moving his large printing presses from space to space, and starting a gallery, the artist shows an unwavering commitment to both his artwork and the community.

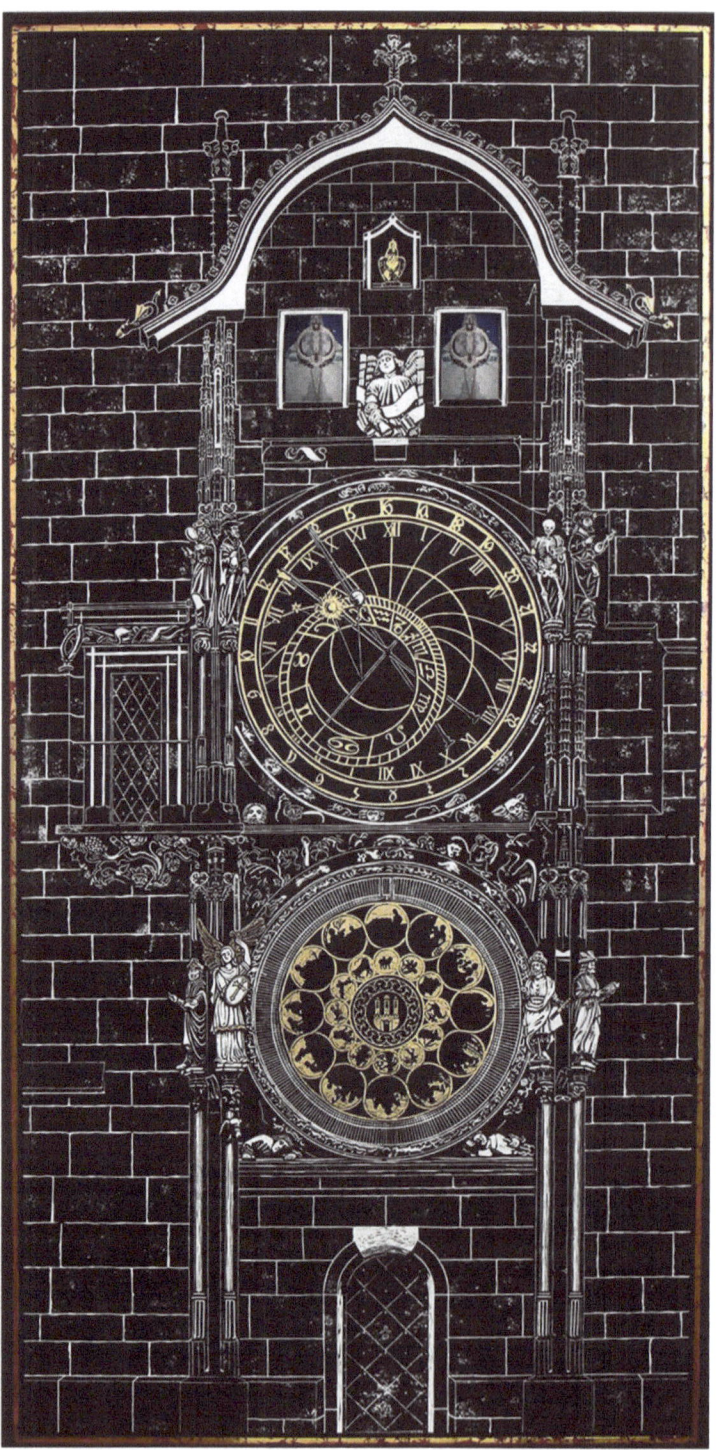

Blind Man's Time Machine, 2002
Linoleum cut on paper applied ink side to canvas & paper removed with two 5.6" video monitors, DVD player & video program DVD (no audio), 74" x 38"

An Interview with Mark

Emily Moores (EM): Can you talk about your relationship to the process of printmaking?

Mark Patsfall (MP): My relationship to it? It is a job. I work with artists, and it is almost always a collaborative process, where there is always a little give and take between the artists and me.

EM: Do you view your job as a collaborator with other artists as part of your art-making or something separate?

MP: I suppose that it is part of my art career. It is tied to that. As an artist, you are always meeting other artists, and moving in that circle.

EM: So you have been dedicated to printmaking and to moving around all these presses all over the city, but then your work tends to include a little bit of everything.

MP: Since most of the printmaking I do is a job, then my own work I can do whatever I want. Basically, as an artist you are free to do whatever you want. I would get bored doing the same thing over and over again. So, if you are printing editions all day, you probably want to do something else with your spare time, if you have any.

EM: You have also been really engaged with the Cincinnati art community. Has that influenced the artwork that you make?

MP: It has influenced the program of the gallery itself and who I publish.

EM: So, it has influenced the job of printmaking versus your actual art?

MP: It hasn't influenced what I make as an artist. I couldn't say that. It does influence what you see in the community and what you respond to and who you invite to make prints and show.

EM: Has moving your presses around from space to space played a role in how you engage with the community?

MP: When the presses were in storage, I always had one press in my garage. I could still work with artists. So, it hasn't really stopped me.

EM: With your own work, I see a sense of time/history.

MP: I am interested in the physics of time, and how we perceive it. What the nature of it is. Those are all questions that are fairly fascinating to me.

EM: Other themes that you focus on?

MP: Usually I try to tie my work to previous art history in some way with references to other characters or artists. Not necessarilty stylistically, but content wise. A lot of my work is time-based, but juxtaposed with the traditional still painting or print, but then has a time-based element in it.

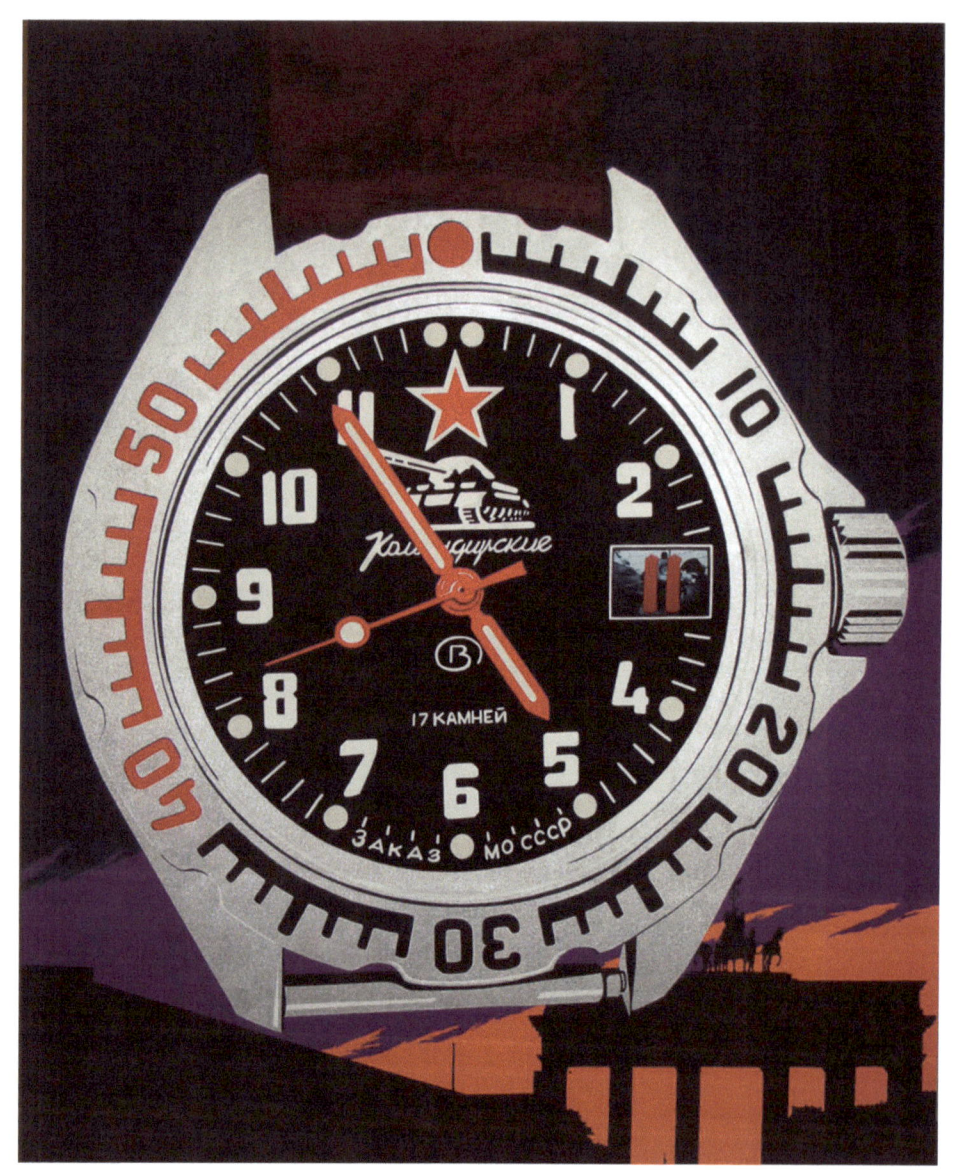

History Repeats, 2011
Acrylic on canvas, 5.6" video monitor/DVD player & video program on DVD (no audio), 60" x 48"

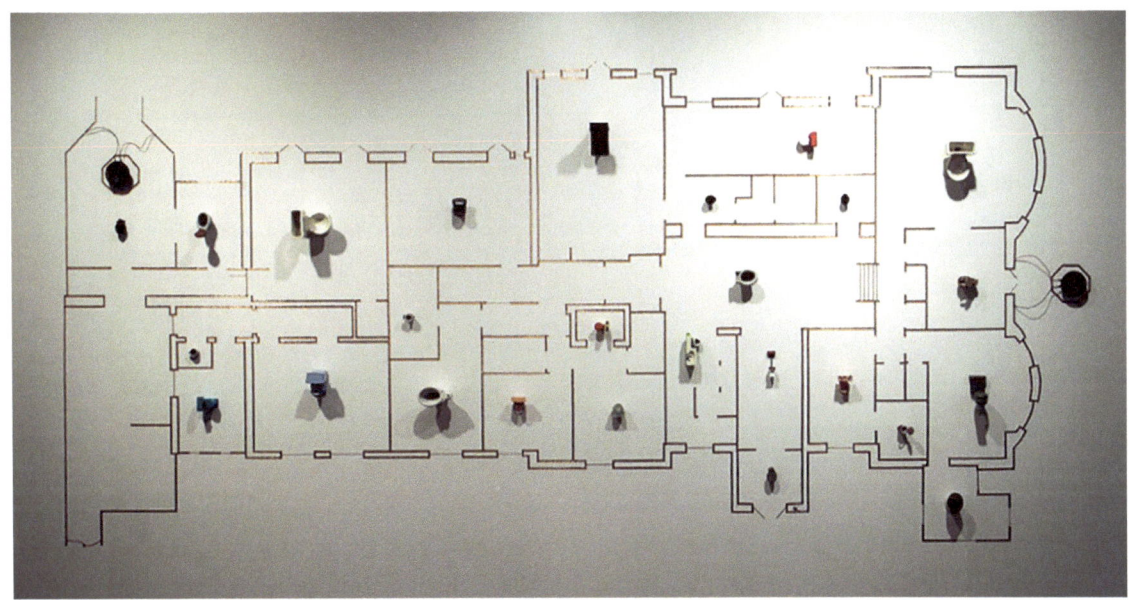

McMansion, 2010
Copper foil tape, antique and toy miniature toilets, 2 speakers, audio amplifier, with audio (flushing toilets), 120" x 43" x 3"

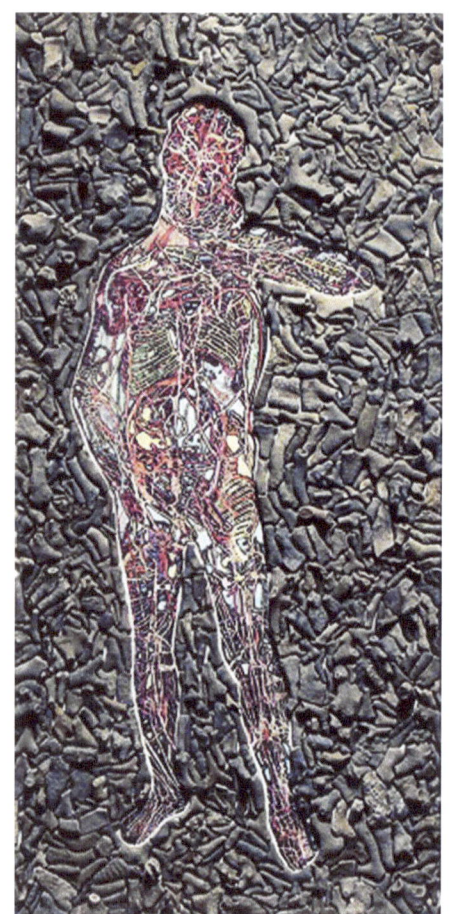 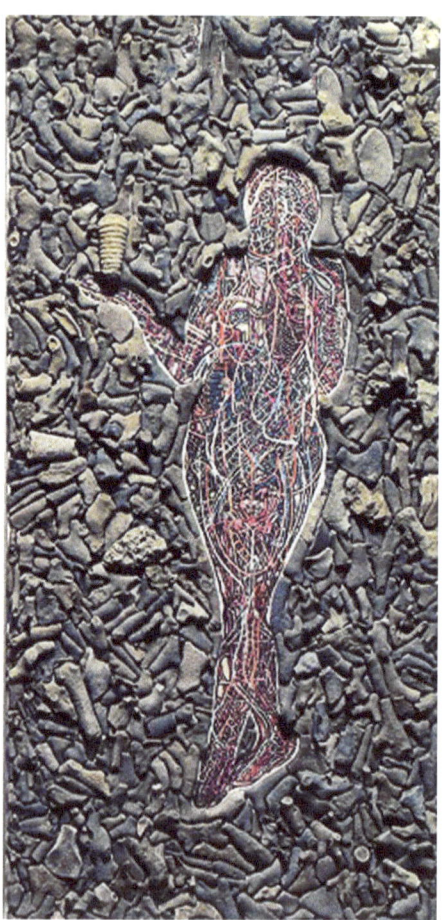

Marcel and Ruth as Adam and Eve, (after Picabia, after Cranach), 2010
Hand colored etchings and fossils on canvases, framed, 12" x 23" x 2" each

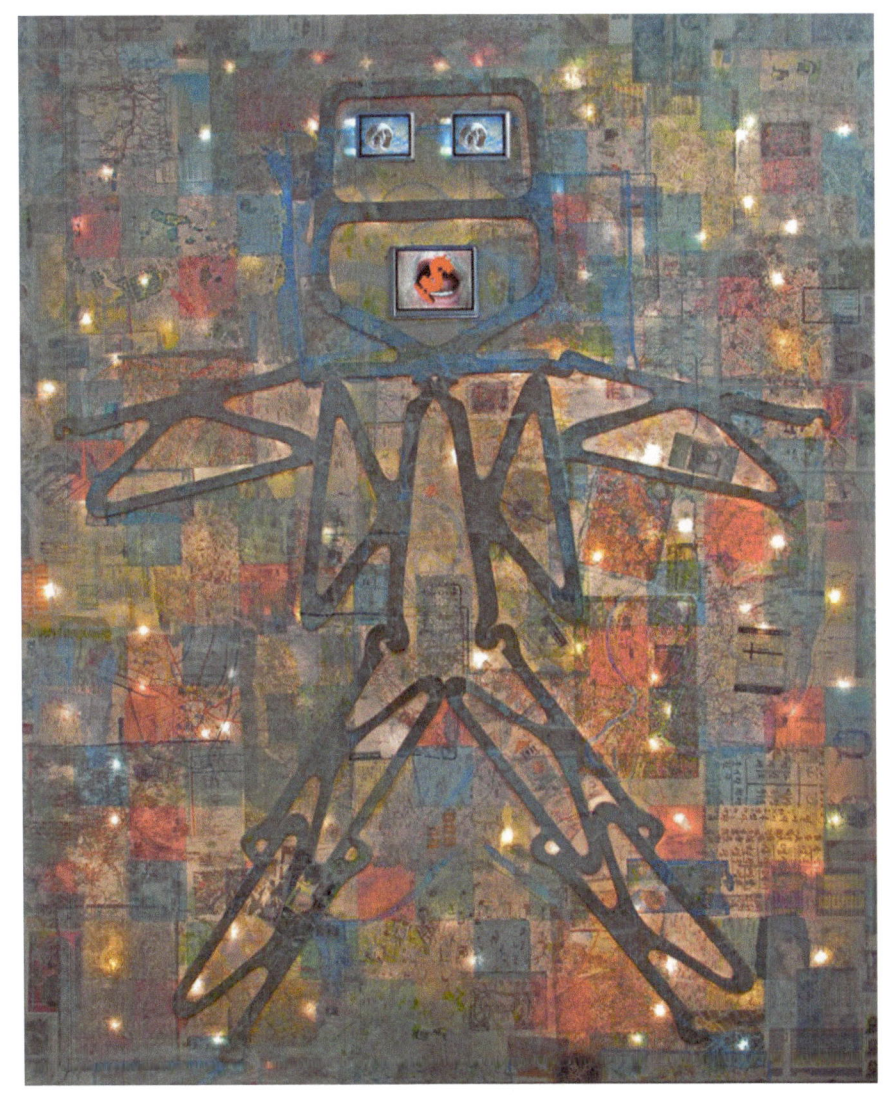

Time Travelling Man, 2004
Mixed media on silkscreen mesh, one 6.5" video monitor, two 4.5" video monitors, two DVD players & video programs on DVD (no audio), electric lights, 74" x 61"

Cincinnati's history, rich architecture and community spirit inspire painter Michael Stillion. He loves Cincinnati's little historical flourishes, such as Over-the-Rhine's (OTR) Italianate architecture, and affectionately refers to Cincinnati as "a little big city." The painter argues that Cincinnati also doesn't hesitate to embrace new voices and work.

Michael moved to Cincinnati with his wife, artist Katie Labmeier in 2007 after graduating with an MFA in Painting from Indiana University, and says he soon found acceptance into the "little big city" fold. He worked as a preparator at the Contemporary Arts Center (CAC) from 2007 - 2014, a Project Manager for ArtWorks (designing murals, ordering paint and ensureing murals are completed on time and on budget), and most recently served as a visiting faculty member teaching drawing and painting at Miami University.

In 2008, Stillion received an Ohio Arts Council grant and was accepted into two residency programs, compelling him to leave Cincinnati for a year. As a resident at the Vermont Studio Center and Artist-in-Residence in Roswell, New Mexico, Michael focused solely on painting.

His work as preparator at the CAC afforded him the opportunity to curate the 2014 exhibition, *Shall I Tell You the Secrets of the Whole World?* which included past or current artist residents of Cincinnati. Stillion centered the exhibition on his interest in the hidden aspects of what a painting can be (sculpture, free standing, woven, etc.) and an interest in the process of painting. To highlight the talent that is coming from Cincinnati, he chose a mix of high profile artists and emerging painters connected to Cincinnati. This mixture brought attention to emerging artists and gave viewers the opportunity to see where the high profile artists are going with their careers.

Michael has worked with ArtWorks—an organization empowering young creatives to transform Cincinnati—on and off since 2007. Through ArtWorks' MuralWorks program, Michael designed and painted a mural across three corners of Cincinnati's Main Street. Together with 15 high school and college students, Michael painted his mural in three parts. At Main and 13th, a precarious, colorful stack of buildings celebrates local architecture. At Main and Woodward, a tall bike celebrates the historic bicycle culture prevalent in Over-the-Rhine. The final component, at Main and 14th, depicts a goat head in honor of OTR's annual Bockfest street fair. "Bock" is both German for goat and a type of beer, connecting Michael's mural to the neighborhood's rich cultural and brewing heritage. All three sections of the mural loudly shout OTR's unique history.

It seems fitting that Stillion's first solo exhibition was at the 1305 Gallery on Main Street—only a stone's throw from where his murals currently stand. New to Cincinnati, he met local gallery owner and art advocate Lily Mulberry. After graduating from UC's College of Design, Architecture, Art and Planning, Lily opened 1305 Gallery as a showcase to local art. Since Lily's death in 2014, a group of artists, including Stillion, have worked to sustain the gallery and keep it open. 1305 holds monthly exhibitions and proudly displays Mulberry's work on the back wall to honor her legacy of commitment to the Cincinnati arts community.

Stillion currently keeps his studio in Evanston and works as a visiting assistant professor at Miami University where he teaches painting and drawing. He has most recently showed at the Phyllis Weston Gallery in Cincinnati and is represented by Linda Warren Projects in Chicago.

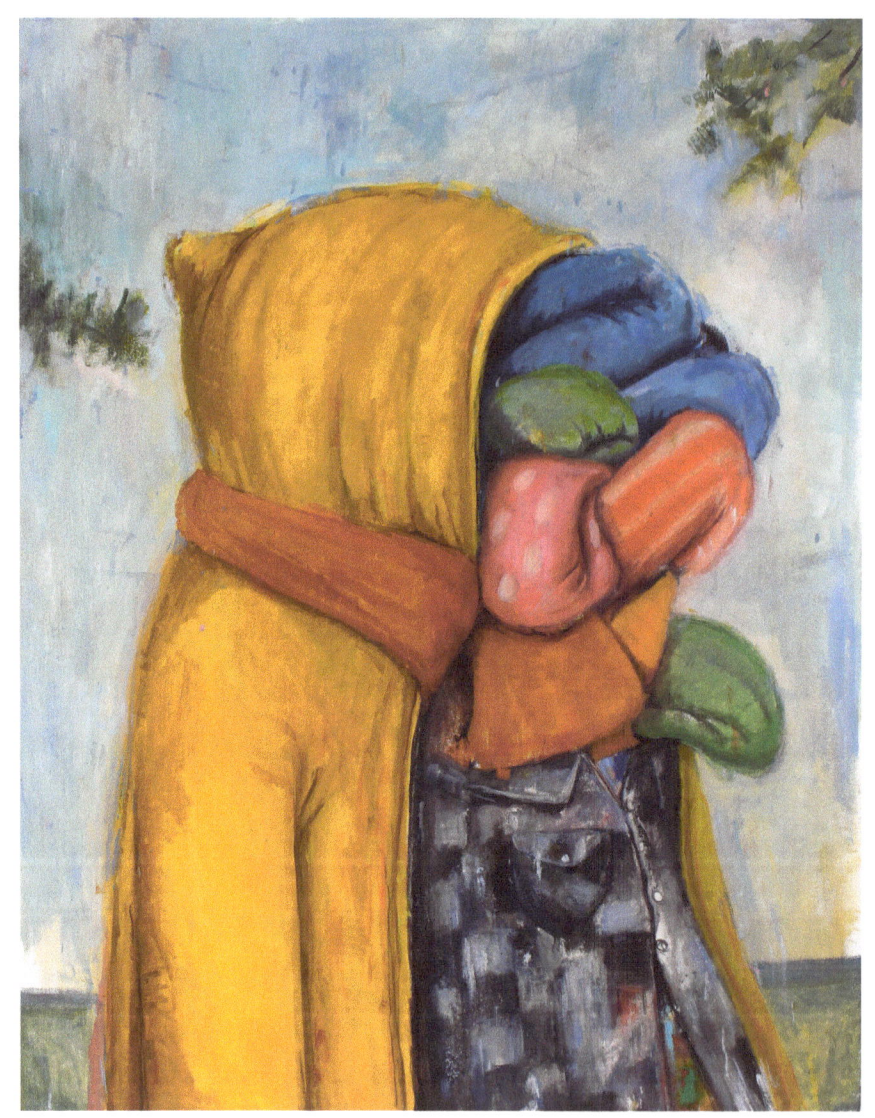

Yellow posture, 2011
Oil on canvas, 38" x 30"

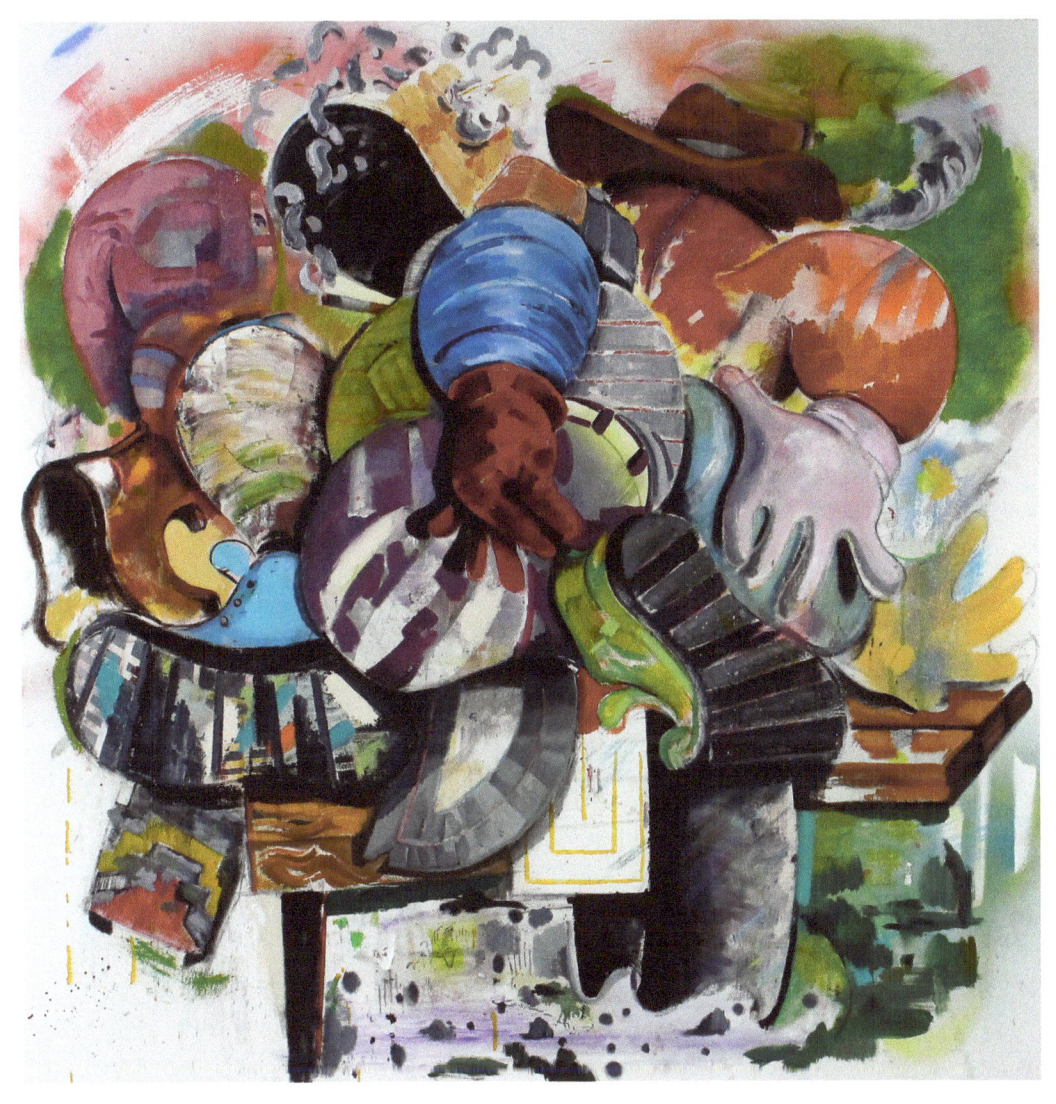

Human Noise, 2015
Mixed media on canvas, 66" x 66"

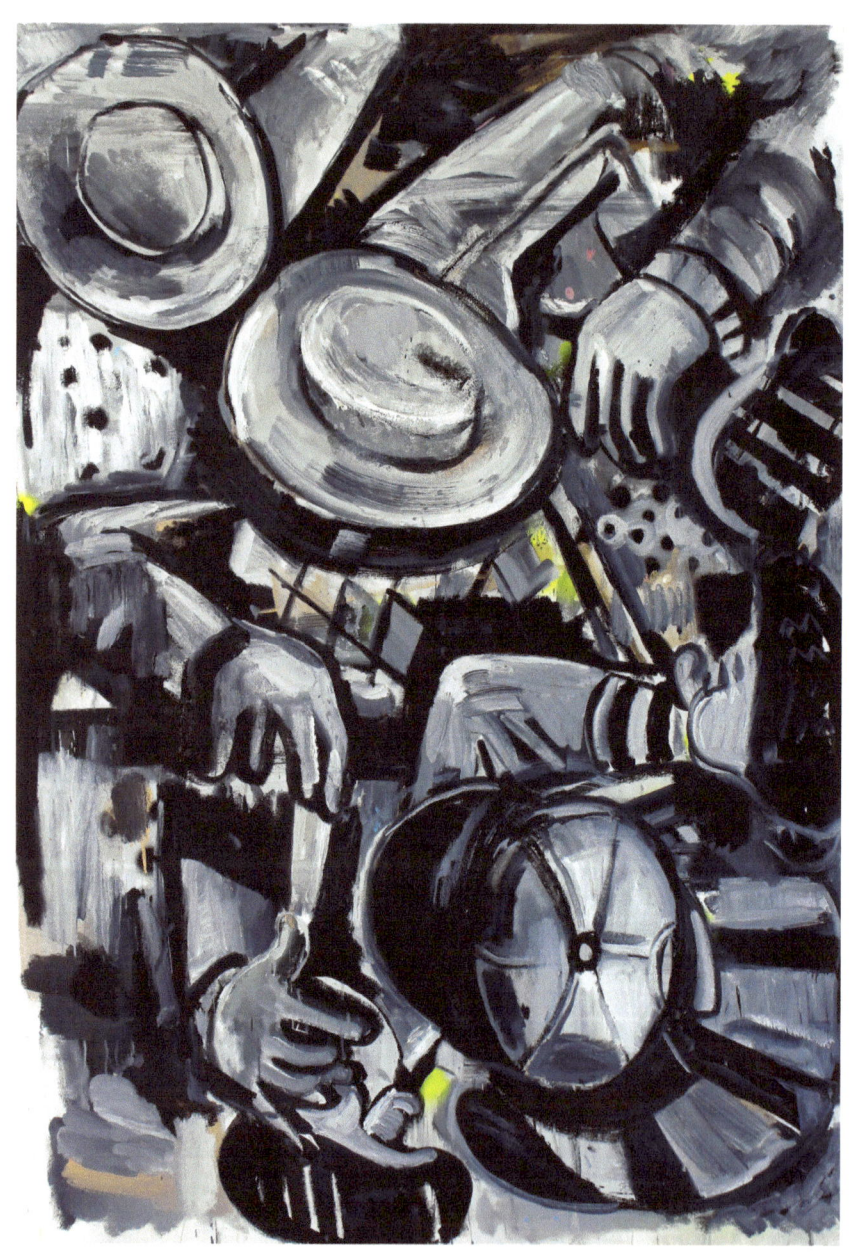

Untitled (grey), 2015
Mixed media on canvas, 66" x 46.5"

An Interview with Michael

Emily Moores (EM): Can you give a brief introduction to the overall theme to your work?

Michael Stillion (MS): What influences my work is magic and ghosts. I like the idea of tricking people into seeing things (that would be the magic). The ghosts would be the idea of the residual - seeing something inside of something. That is kind of what a ghost is to me. The idea of what used to be, what is present

EM: Your paintings look playful. Do you have a playful connection to magic and ghosts?

MS: I think there is more of a humor with them, but within that humor is a seriousness. I think that the best humor comes from reality. The best comedians are usually the most depressing.

EM: You mix the two spaces of abstraction and realism. Does that play into the magic?

MS: I guess so. It arcs between the two. Pushing the abstraction to a certain point, I start to find a realism to it, and pushing the realism in something, I find the abstraction. As I am painting, I may find something and latch onto it, but then a viewer sees it or becomes engaged with the piece, they start to impose their own reality onto it. So then their ghosts start to come out.

EM: How do you chose what ghosts to put in your paintings?

MS: I think that every day it changes. The ghosts that started the paintings from 2007, when I started making improvisational construction paintings, those came from my childhood. For a long time I was in denial as to where I came from. When you go to college, especially when you come from the country and you move to the city... I was in denial about that. There were good stories, but I never saw myself in those. In the way that I describe where I was from, I was always trying to reject it. When I got to grad school, I was making paintings of still lives and landscapes. There was a switch. I had all these skills, I know how to paint a landscape, I know how to paint a figure, but how do I make it my own. I went home for a visit and I was driving around with my dad. All of the sudden, I started seeing these garages and sheds that were barely standing up. They were always there, my whole life. Even when the place would flood, it would wipe out the houses. When the water would go down, the shed was still there. I got interested in these pieced together things. The sheds had 2x4s propping them up or there was a tarp draped over it for a door. This is where I started applying myself to my work. That is where it really started to come out. This is where I started to become aware of those ghosts.

EM: Is there any advice for anyone who is intimidated by looking at abstraction?

MS: I think they need to look at it for what the material is, too. So if they approach a painting, look at how the material is used. Maybe they can see a drip or a mark is made. Look at how it is made. Don't go into it with any preconceived ideas. If you go into it, thinking that you have to see it one way, that is going to be dangerous for you. You are going to shut down so much stuff. So step back thirty feet, look at it from a distance, become interested in it. Go fifteen feet closer, let it develop into what it is. Then try to get as close as you can. Look at how the painting is made. For me, I want to walk up to a painting. I love being drawn into it. Appreciate it from far away. Appreciate it from half way. Appreciate it up close.

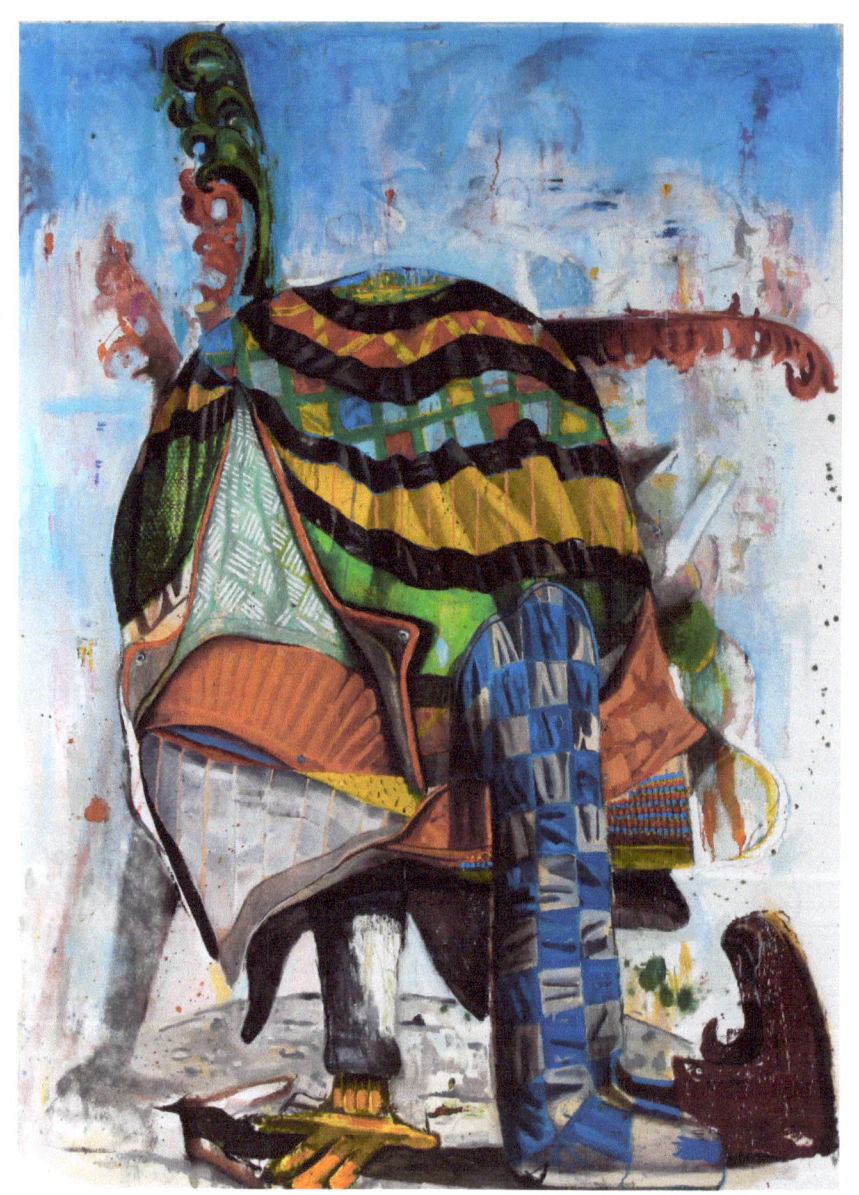

Push, 2014
Oil on canvas, 56" x 42"

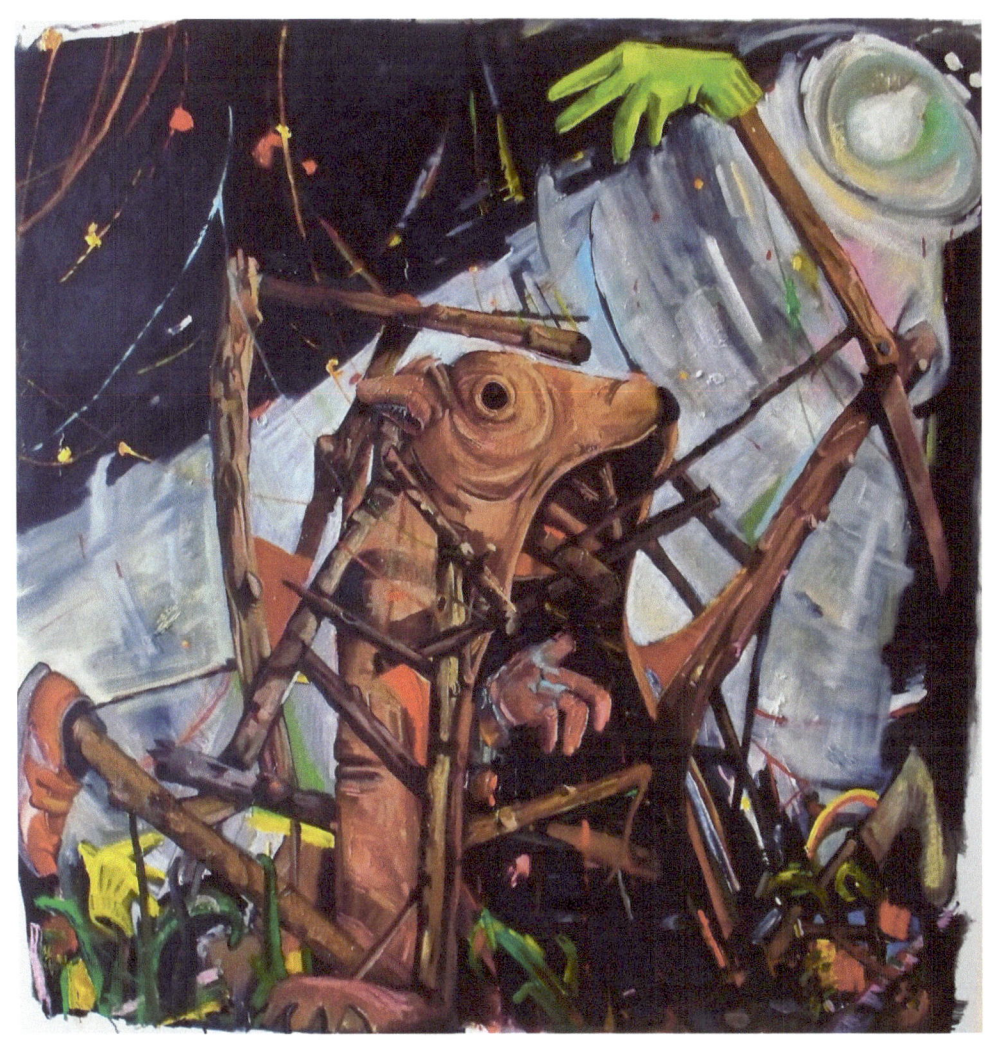

Bear hide, 2010/11
Oil on canvas, 48" x 48"

TERENCE HAMMONDS

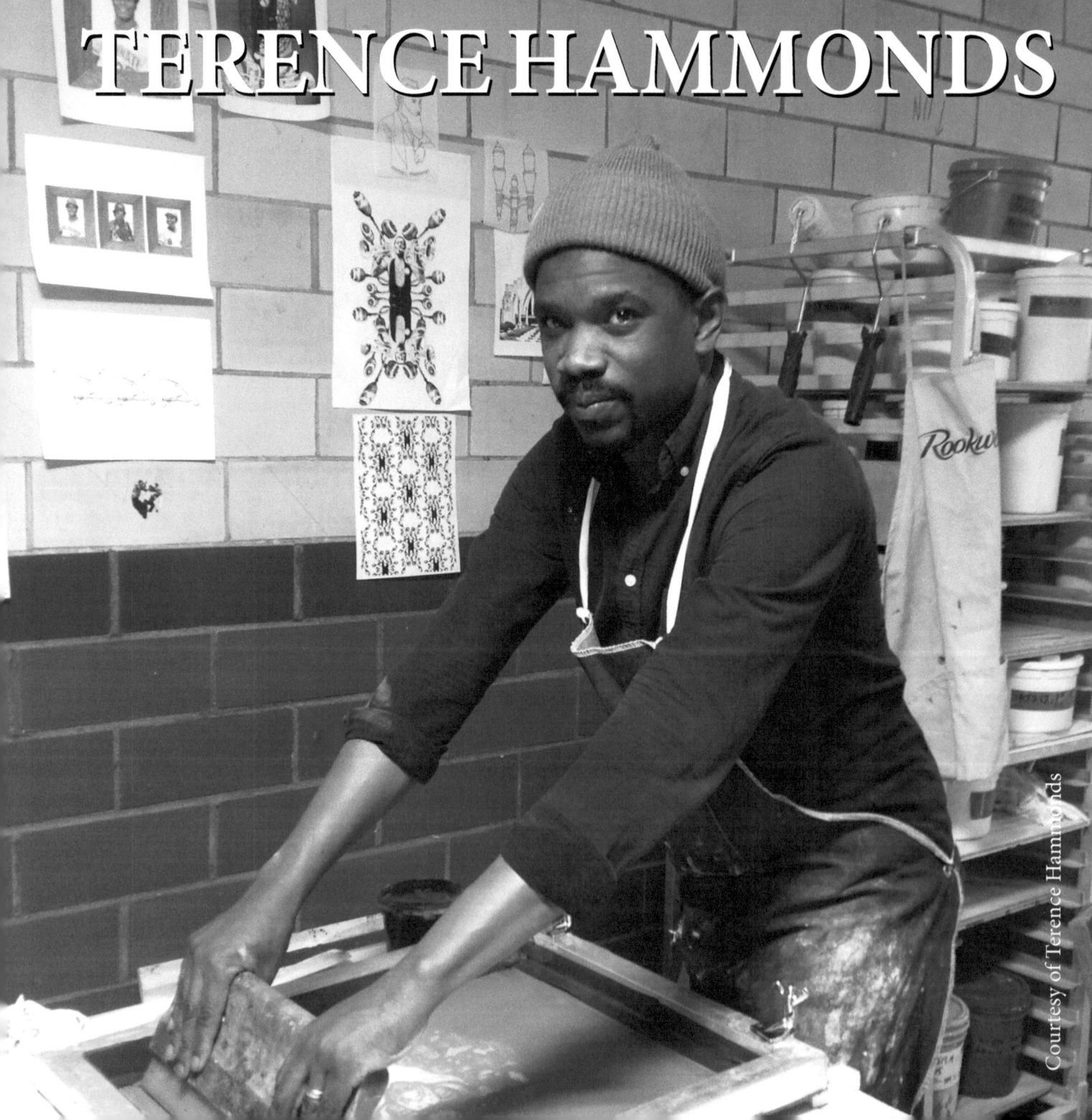

Courtesy of Terence Hammonds

The art of Cincinnati native Terence Hammonds draws heavily from the community and spaces that molded him. Hammonds' childhood home in Over-the-Rhine (OTR) was rich with heavily patterned wallpaper and wainscoting. From 4th grade through high school, he attended the School for Creative and Performing Arts, a 19th century building covered in murals, decorative wallpaper, and stained glass. During his senior year, the aspiring young artist found work at Clay Street Press as Mark Patsfall's assistant and assisted editioning etchings for Nam June Paik.

Informed by the rich textures of his home and school, Hammonds focused his high school studies on the visual arts and printmaking. He made a concerted effort to commit four hours of each day to making his art. Thinking he could not afford college, Terence spent six months in Clifton working with Patsfall and a subsequent six months couch-surfing in New York City. With some convincing from friends, he attended a college art portfolio day and was accepted to three universities on the spot. Hammonds chose the college with the best scholarship offer: the School of the Museum of Fine Arts (SMFA) in Boston, with academic courses at Tufts University.

In 2001, SMFA awarded Terence a $15,000 traveling grant for graduating seniors. He used the grant to travel to Italy, where he assisted Cuban-born artist Maria Magdelana Compos-Pons during her exhibition in the Venice Biennale. Afterwards, he stayed in Boston to assist Campos-Pons with the installation and de-installation of works, setting up projectors, and folding fabric before moving back to Cincinnati in 2002.

Upon his return to Cincinnati, Hammonds resumed working with Patsfall at Clay Street Press as a printmaker. In his position as an assistant to Patsfall, he ran the silkscreen department, made editions from plates, and experimented with ink-relief prints. This experience led to his current job working at Rookwood Pottery, where he runs the silkscreen department and organizes the interns. And, much like his previous experiences of being influenced by the spaces he inhabited, Rookwood Pottery's studio in OTR has also greatly influenced his own artwork: he now designs and prints on ceramic bowls and vases.

Hammonds loves Cincinnati and Rookwood for their historical presence. This rich sense of place drives his creative spirit. For example, one of his installations with Future Retrieval involved making printed tiles inspired by antique paperweights. His youth in historic Over-the-Rhine engrained this sense of time and place in Terence's art.

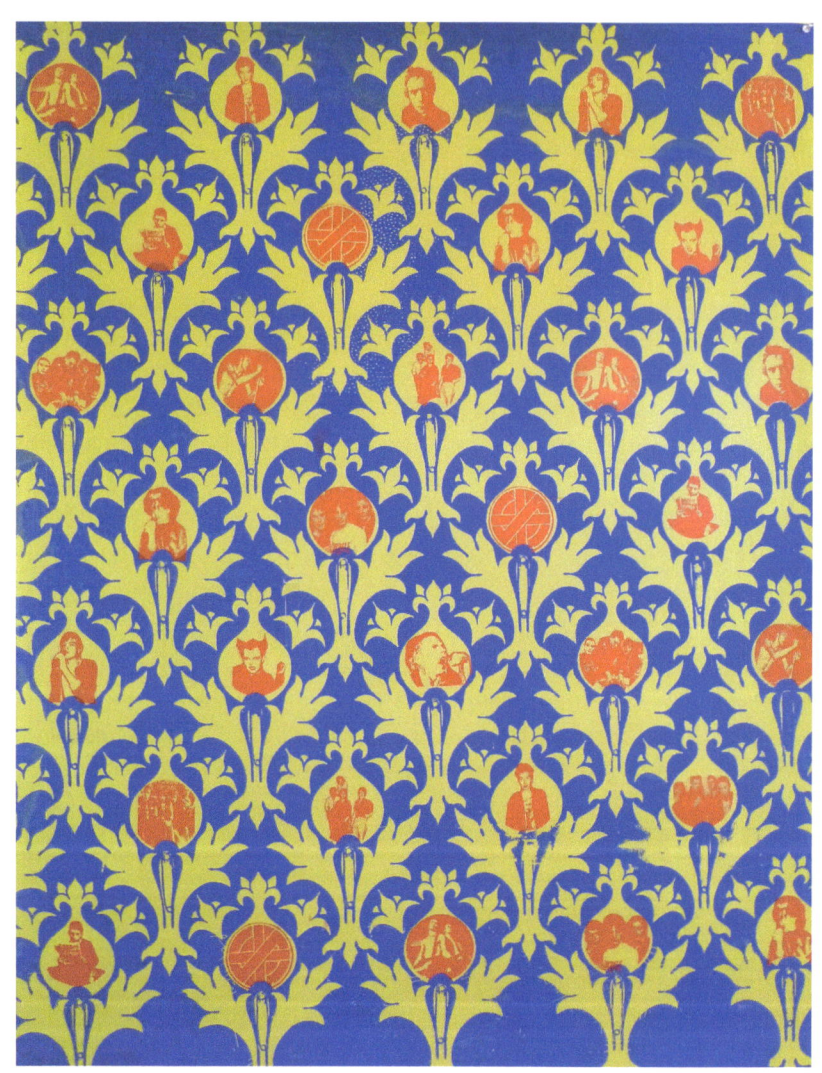

Do they owe us a living? 2011
Screen print on paper, 30" x 40"

An Interview with Terence

Emily Moores (EM): You were influenced by the patterns you were surrounded by in your childhood. Can you talk about the way you use patterns in your art work?

Terence Hammonds (TH): Some of the patterns, like the *Biker Couple*, the pattern in the background is from the plantation where *Gone with the Wind* was filmed. I actually originally did the pattern when I was in college and there was a video on BET that was by Mystikal and it was *Shake It Fast, But Watch Yourself*. It was this base level song about booties and strippers, basically. I thought there was an interesting thing that was happening with culture and this former plantation being used for this raunchy song. I videotaped it, paused the video and did a drawing of the pattern. One of the iterations [of the drawings] it was a large wallpaper pattern ... Also, in the pattern, are silhouettes of people break dancing from the first *How to Break Dance* book, which was published by Avon in 1982.

EM: Are all of your patterns a personal reference?

TH: Yes. The pattern from *Stand up! Organize* from a Polish tapestry, and the dance floors from *Get Up Stand Up* are a dance floor from a palazzo in Italy. It is the descending cube pattern that is really popular, that's just where I saw it.

EM: Are the historical references something that are important to you or is something that you are interacting with?

TH: It depends. For the *Biker Couple* or *Beat Boys Breakdown*, I think that it is really important where it came from and that whole story, and all the elements that make up that pattern. I think the original pattern in *Stand up! Organize* maybe not so much. I have also used patterns of peace. For *Playing the Wall*, the embossed pattern has some illustrations from the Quran, and I wanted to use these patterns that symbolized peace and harmony and juxtapose them with the disorder that was happening in the civil rights movement. There is another piece that is not included in this, but I did on Trevon Martin for Sarah Vance, a collector. I used the same pattern from the Quran, and trying to force this thing that I couldn't understand into a pattern, to make it make sense to me. A lot of what is happening is just cutting up these images from popular culture and forcing them to make sense. Putting them in some sort of order.

EM: Can you further elaborate on juxtaposing the peaceful imagery with imagery that are causing turmoil?

TH: I don't know if there is a goal, or if it is just my brain's way of organizing . Clearly those patterns have beauty. I think if I take this ugly thing and force it into a beautiful pattern, it may make more sense to me. There is something really cathartic about that exercise. Especially for Trevon Martin, all that happened around the time I had my son. It was really easy for me to project myself into his parents' position, and how hard that must have been. For me, it was the only way of understanding that and getting through it.

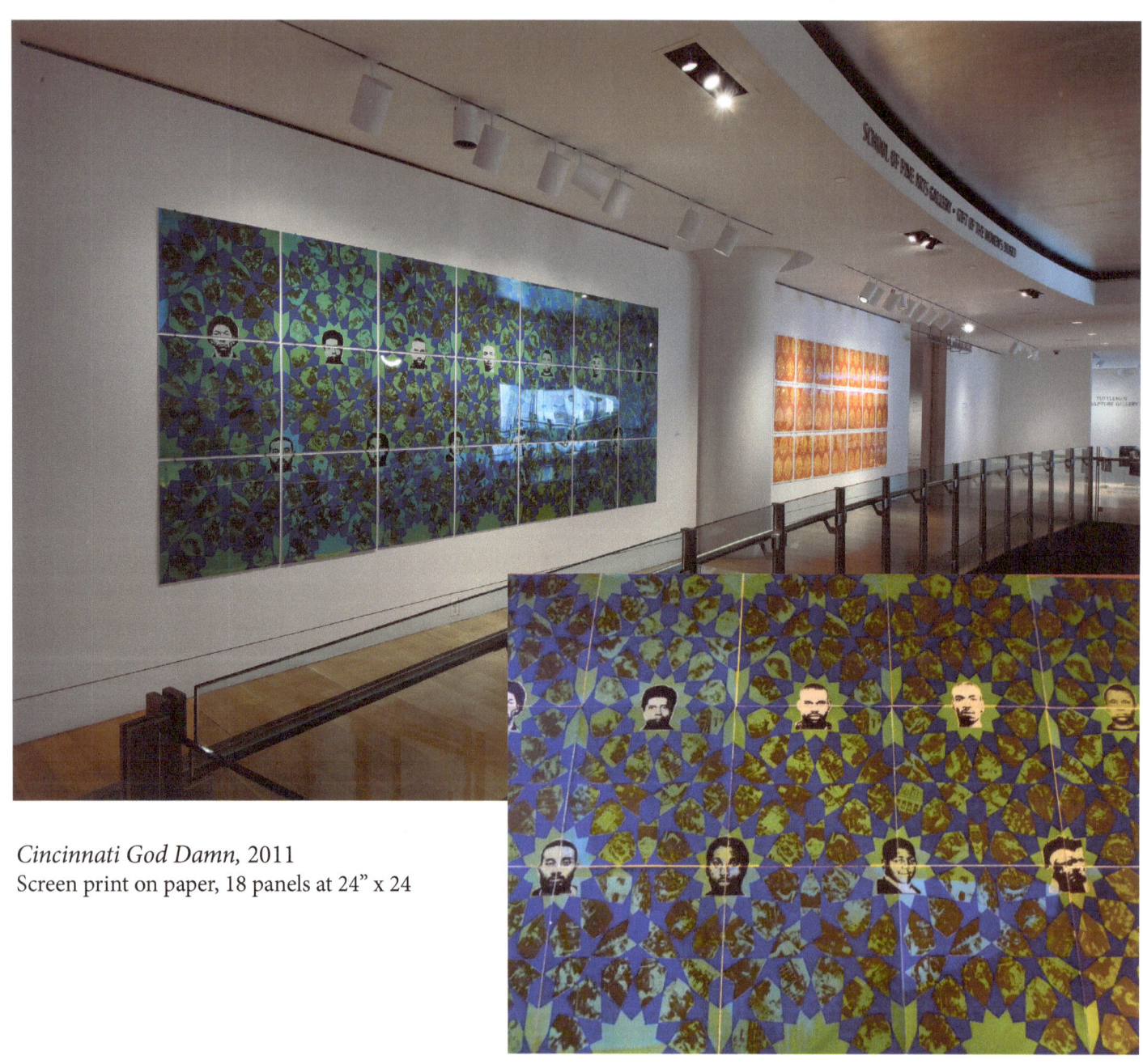

Cincinnati God Damn, 2011
Screen print on paper, 18 panels at 24" x 24

Cincinnati | 26

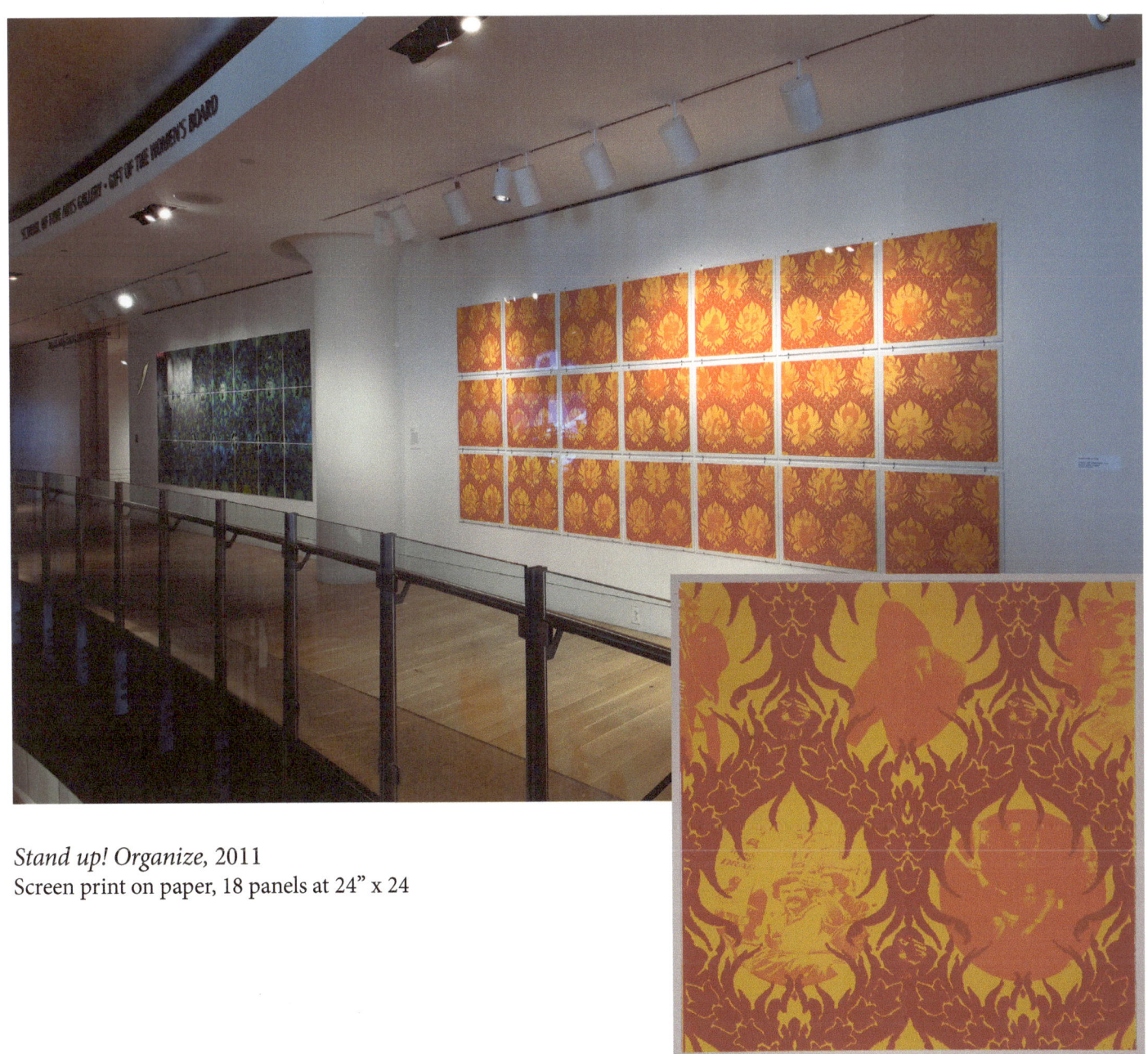

Stand up! Organize, 2011
Screen print on paper, 18 panels at 24" x 24

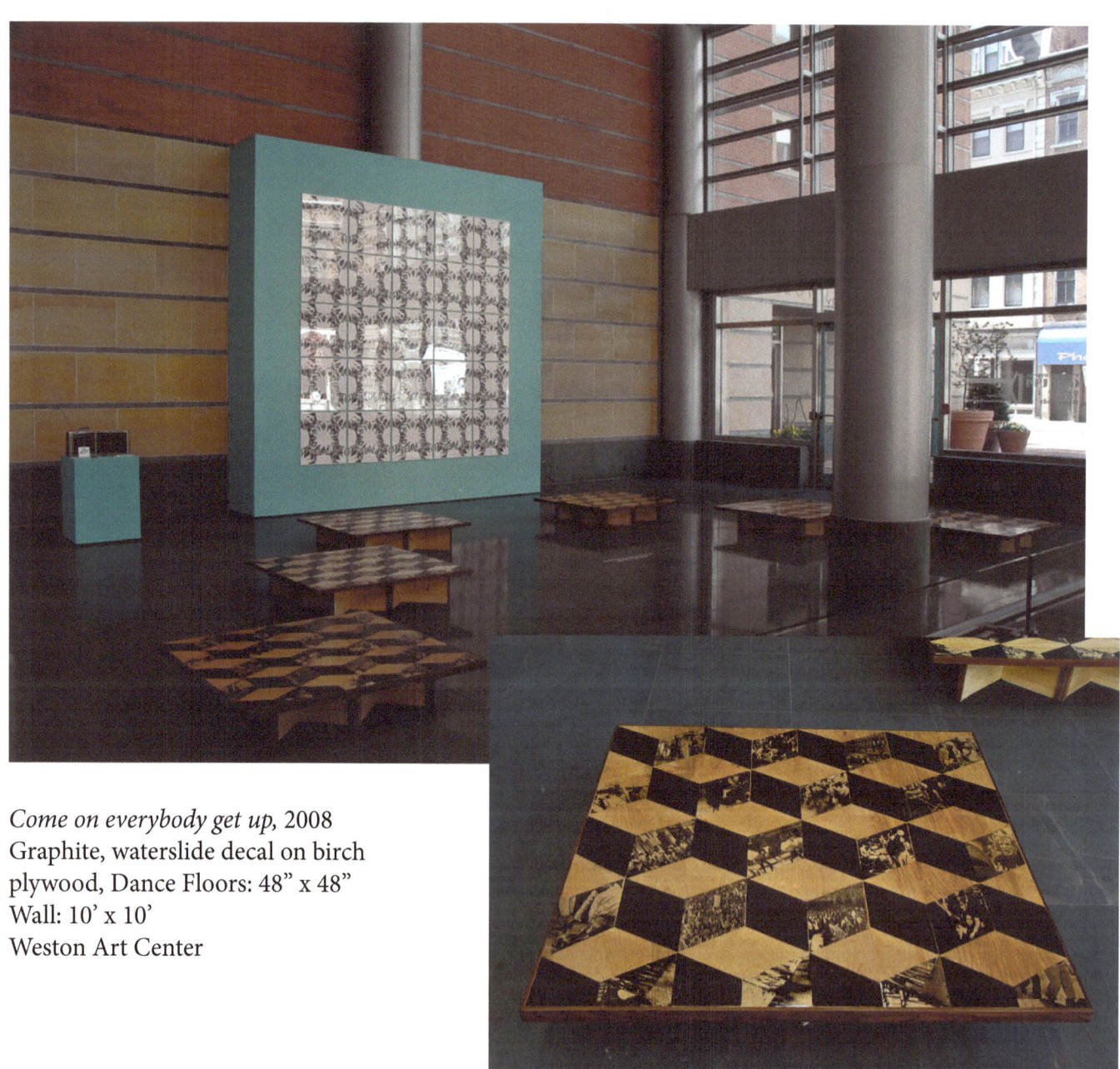

Come on everybody get up, 2008
Graphite, waterslide decal on birch
plywood, Dance Floors: 48" x 48"
Wall: 10' x 10'
Weston Art Center

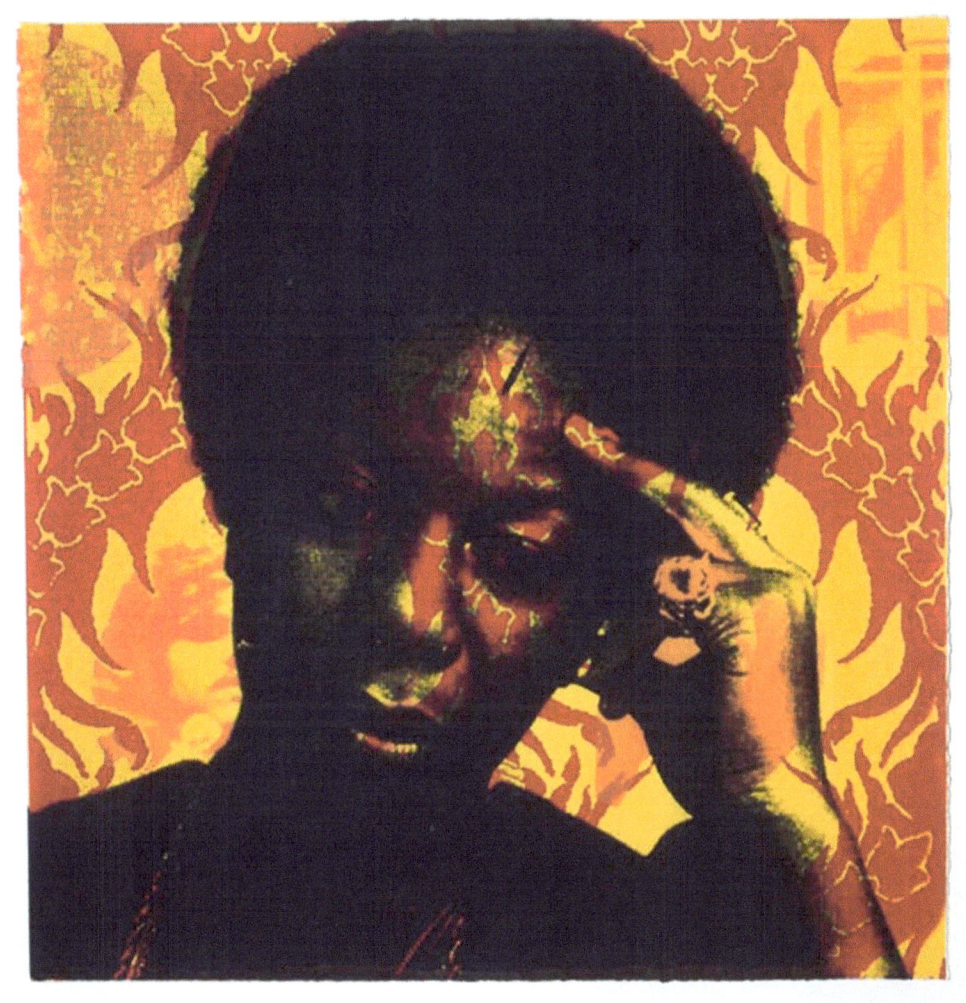

Nina, 2012
Screenprint on paper, 24" x 24"

PAM KRAVETZ

Courtesy of Cincinnati Enquirer, Photographer Amanda Rossmann

Pam Kravetz's life is not one easily defined by a single personality characteristic, nor has she followed a predictable career path. As a ceramics and drawing student at UC's Design, Architecture and Art program (since amended to include Planning), she joined a sorority, received varsity letters as UC's Bearcat mascot, and was nominated for homecoming queen.

After college, Kravetz assumed she would follow a well-worn career path: waiting tables to fund her art. To her surprise, however, she found that she enjoyed waitressing too much and made art too rarely. Not knowing how to advance her career, she became a docent at the CAC and the job sparked her passion for working with people and art. Inspired, Pam earned a Master's degree from Miami University in Fibers.

As she began a career in teaching, Pam noticed her first-grade art demonstrations filling entire lessons instead of the recommended five to ten minutes. Watching her students make their art projects made her feel oddly jealous. Realizing that artistic creation was an integral part of her life—and something she missed since college—Kravetz began showing small ceramic works at artist run holiday craft shows.

A 36-year-old single mom with no clear vision of her artwork, Pam took an encaustic painting class with Susan Fischer to develop her skills. Her first series of paintings humorously depicted the challenges of potty-training her young son. Encouraged by Fischer, Kravetz took additional courses, including a narrative-quilting course, which led to her first exhibition: a juried quilt show at the Dayton Nature Center. She participated in this annual quilt show for the next ten years.

But Kravetz's true influence on the Cincinnati art community got into full swing with ArtWorks's Big Pig Gig: Do-Re-Wee in 2012. For this public art project, she worked behind-the-scenes on the installation of hundreds of full-size fiberglass pigs. Over time, the artist's relationship with ArtWorks spread to mural projects. This provided Kravetz with the opportunity to create an installation piece for Cincinnati Children's Hospital. The hospital subsequently hired Pam to work with patients, helping them to create their own quilts to tell their stories.

Her time with ArtWorks and Children's Hospital helped the artist refocus on developing her own work. In 2007, Kravetz had her first museum exhibition in the "Unmuseum" at the CAC. For her show in this interactive, youth and family-focused gallery, she created three, eight-feet-tall puppets that children could manipulate: a beauty queen, a superhero and a peanut.

Be it installation, performance or narrative quilt, Pam is quick to praise those who help her create. This connection to community unintentionally molded her into a performance artist under the guise of "Pinky Shears", the leader of "The Cincinnati BombShells." Starting with thirteen people, the BombShells evolved into a "yarn bombing" group of women who dress in blonde wigs and install their art in the public sphere, covering the outdoors in knitted yarn. Their works have been up in sanctioned and unsanctioned public spaces alike, including (but not limited to) the front of the Contemporary Arts Center and the entire stretch of green space on Central Parkway in 2011.

No matter her accolades, she seems quick to praise the individuals who she collaborates with, and often assist her epic art projects. The dedication and sincerity of Pam's art is a refreshing break from the idealized notion of accomplishment and success in the art world.

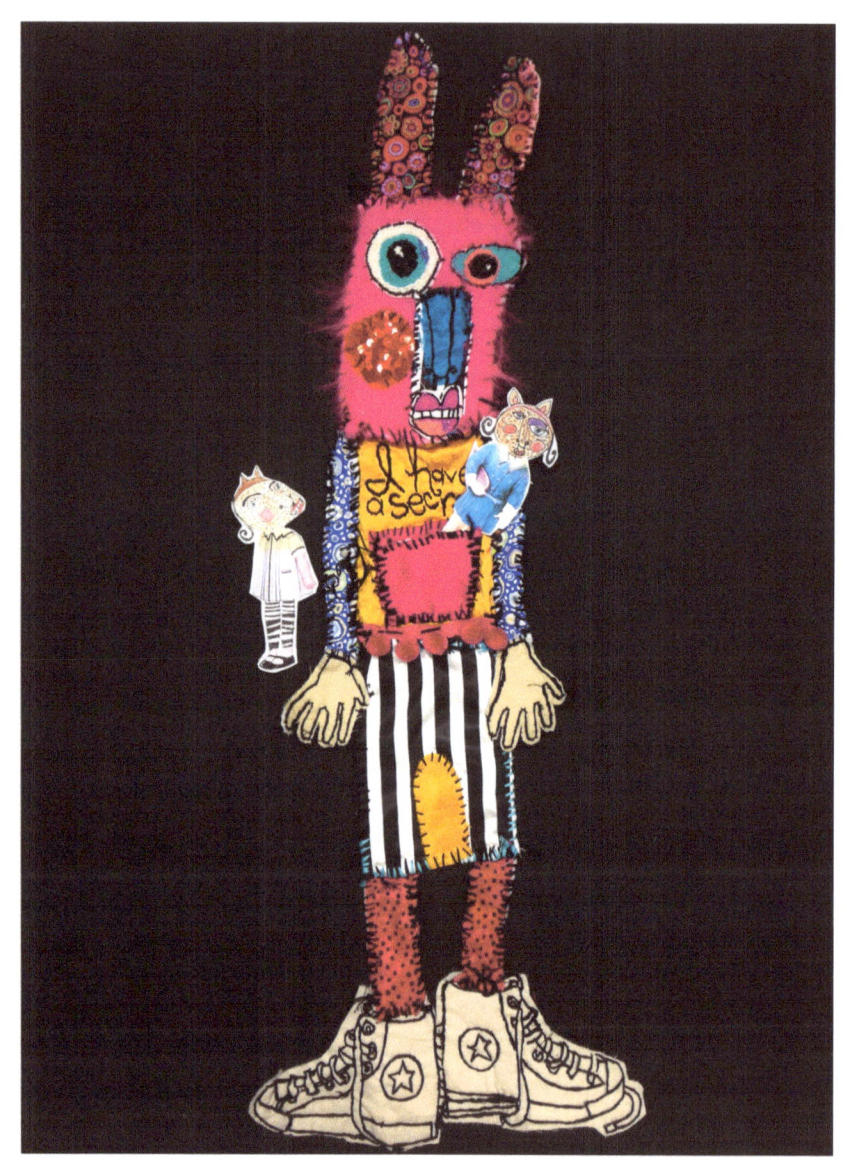

I Have a Secret, 2014
Narrative quilt and paper dolls, 7" x 24"

An Interview with Pam

Emily Moores (EM): Can you talk about how your first class that you took after receiving your teaching license gave you permission to make funny artwork?

Pam Kravetz (PK): I went to UC (DAAP), and everything was heavy. I actually went out to dinner the other night with my old sculpture teacher, and we were just talking about it. Everything was very dark, and very heavy and very servious. I wanted to be like that but I didn't have it in me. It didn't work. So, I did what I did, and I tried to fit in, and it never quite happened. And then I wasn't making art for a while, and I went back and got my teaching certification. I started teaching, and I went back for more classes. I loved to learn. So [I took] the class with Susan Fischer, who is an artist in Cincinnati, and it was in encaustics. Encaustics is a such an aged modern art form, and the Roman sculptures were painted in encaustics. It has this history and this elegance and this importance to it. My son was three, and he wasn't potty trained. I was a single mom. All I could think of was Max not being potty trained. What should I do? Everyone else in the class was doing this serious art. The only thing I can think about is potty training. Everyone else is putting up their art work, which was serious and beautiful and elegant and smart. I am putting up my art. Suzanne was great. She said, "These are great. No, these are really funny, and they're poignant, and they are personal." And I said, "Yeah, I know, but who cares." I didn't have a voice, or a reason or anything to tell anybody. She said this is what you need to be doing art about. So she gave me the license to make art that was just about me and my life.

EM: You describe your work as childlike and not childish, can you describe the differences?

PK: My art is childlike in that I like the innocence. I don't pay attention to perspective. I don't necessarily use flesh tones. I know how to shade. I have a drawing background. I know all of those things. I know where the darks and the lights are, but I don't want that to enter into [it]. Somebody described me once as being the most over educated outsider artist they ever met. So the idea of an outsider artist, not having any formal education. I have a ton of formal education, but I really gravitate towards the primitive, the unfinished and the unpolished. So that to me is the childlike, and the playfulness of the color. The perspective doesn't matter, and size doesn't matter. How does everything work together? I don't erase anything. I will cross it out with a stitch or add on top of it, but everything, the story the history is constantly there. So very much like a child. I made a ton of mistakes, but I don't necessarily fix them in a traditional way. I don't erase them. I don't re-do it. I add to it.

EM: In recent years, you have begun to make performance art. How does your relationship with the viewer change from traditional 2D art to performance? Does the viewer play a different role for you?

PK: So through the BombShells, we found out that people like to watch us. Realizing that I liked that, I liked people watching me do what I do. That lead into the whole performance thing. The performance is that much more related to the person. So I am almost becoming my artwork. At one point the art could stand alone, and still be a beautiful piece and a finished piece of art. Now I feel like I have to be there. I have to be part of what is going on for you to interact with the work. It is becoming more viewer-centric.

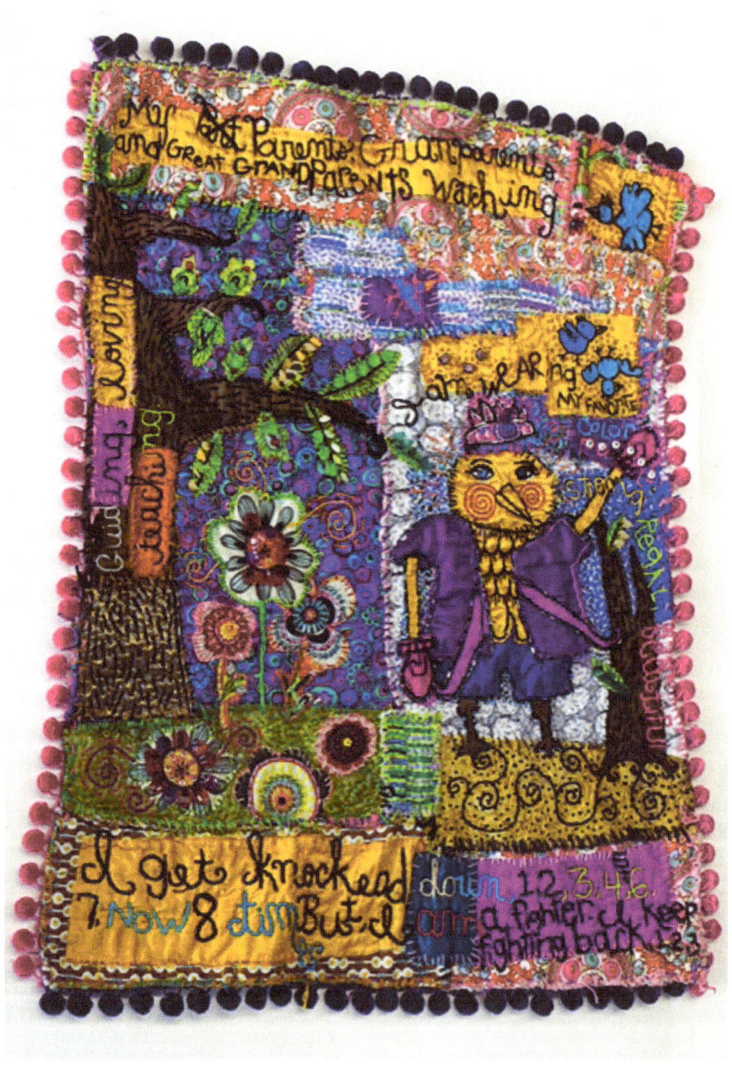

I Get Knocked Down and I get Back Up, 2014
Narrative Quilt, 24" x 30"
Cincinnati Children's Hospital and ArtWorks of Cincinnati Collaboration, Art RX

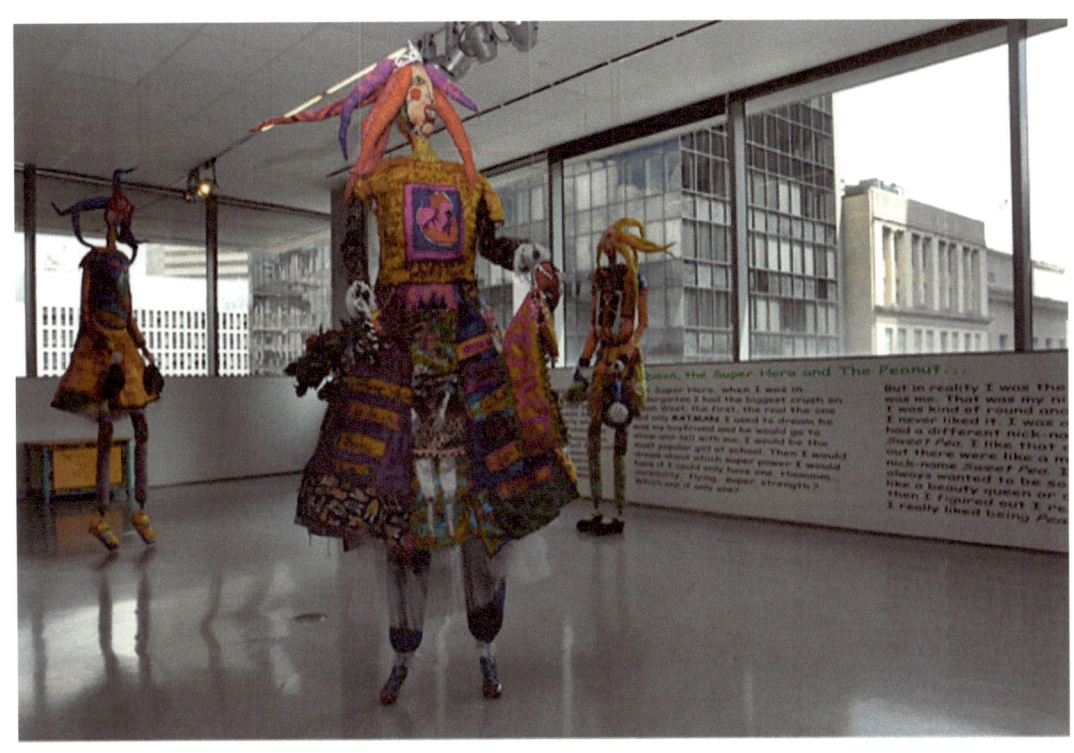

The Beauty Queen, The Super Hero and The Peanut, 2008
Interactive Installation, 8' x 4'
Lois and Richard Rosenthal Museum of Contemporary Art, UnMuseum

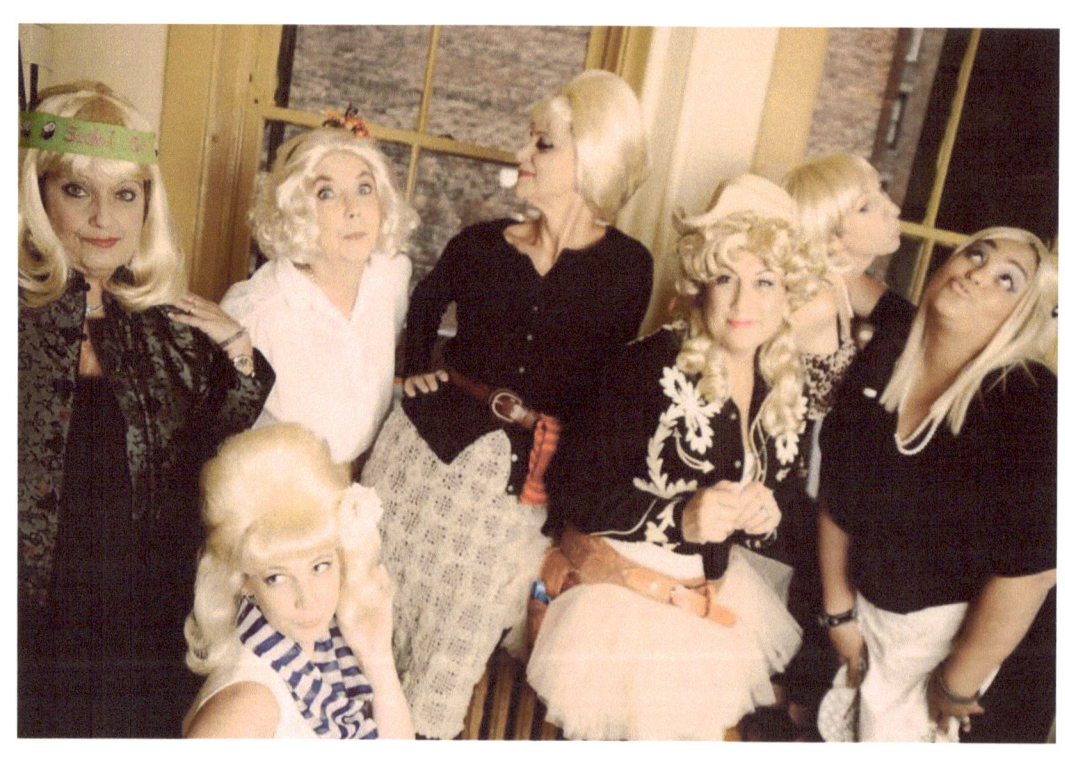

Bombshells of Cincinnati 2010
Yarn Bombing Photoshoot at Arnold's Bar and Grill, Cincinnati, Ohio

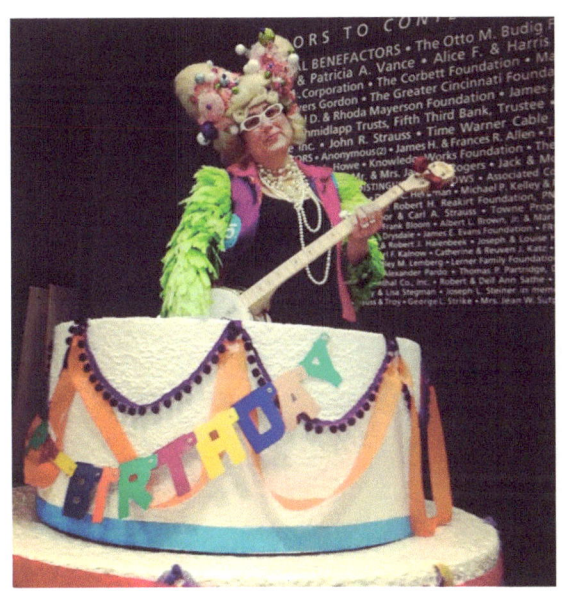 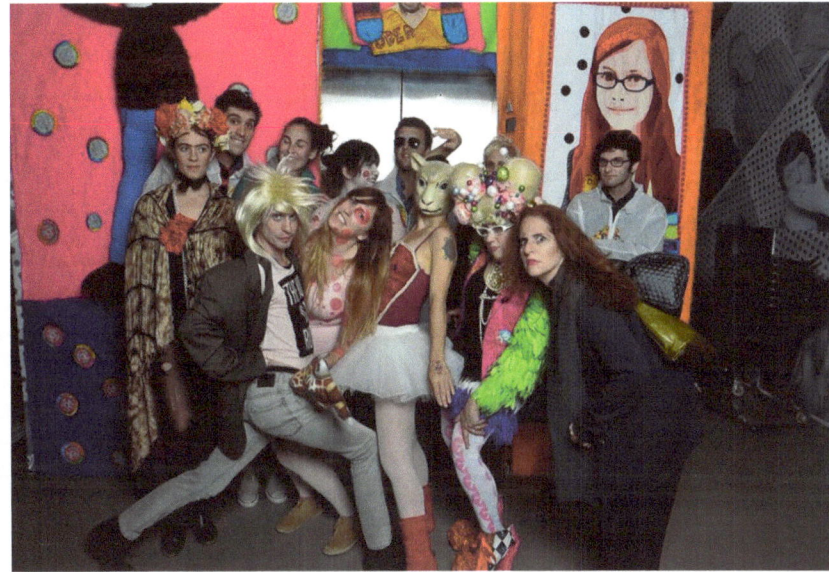

CACtv 2014
Live, interactive art installation
Lois and Richard Rosenthal Museum of Contemporary Art, 75th Birthday Celebration

FUTURE RETRIEVAL
KATIE PARKER & GUY MICHAEL DAVIS (MIKE)

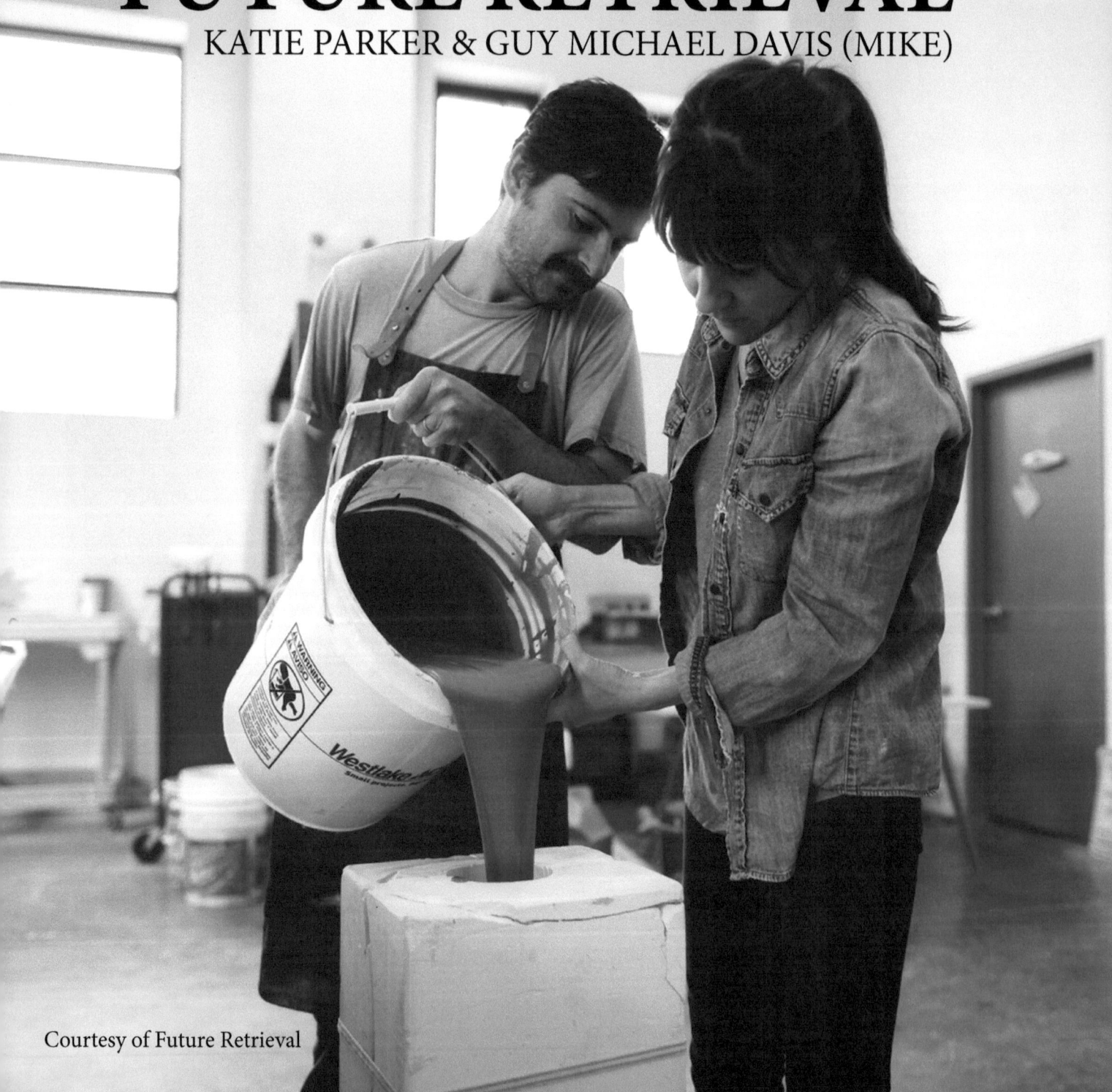

Courtesy of Future Retrieval

Future Retrieval's name came about jokingly when couple and artistic collaborators Katie Parker and Guy Michael Davis (Mike) browsed their Sallie Mae student loan paperwork. What if their artistic collaborations sparked value they might want back later? Creatively spun from that concept, Parker and Davis "retrieve" things from the past and reinvent them for the future. The duo often delve into art history, their work typically a wholly collaborative effort. Even when the two ceramicists work alone in their joint studio, the fruits of their labor go collectively to Future Retrieval.

Katie and Mike say they felt immediately welcomed upon moving to Cincinnati from Columbus in 2008. The outpouring of support from local curators and galleries was like nothing they'd ever experienced before in another city. In 2009, they received the Cincinnati Individual Artist Grant from the city of Cincinnati for $3,300. This grant allowed them to make larger installations, including a cut-paper and neon chandelier. David Rosenthal, owner of Prairie Gallery in Cincinnati's Northside neighborhood, first saw Katie's work during a public presentation at UC. In 2010 he offered Katie and Mike a show and encouraged them to push their ideas to their artistic limits.

The Prairie Gallery exhibition led to an exhibition at the Cincinnati Taft Museum, which in turn led to the purchase of their work, "Small Still[ed] Life" by the Cincinnati Art Museum. Based on the Taft Museum's Balthasar van der Ast Dutch still life, the work is currently on permanent display at the Cincinnati Art Museum, surrounded by Dutch still life paintings.

In 2013 the Contemporary Arts Center featured Future Retrieval in their "Living Room" exhibit, curated by Justine Ludwig. One of their installations, a ceramic tile fireplace made in collaboration with Terence Hammonds, paid tribute to historical ceramic designers with local roots.

According to Parker, ceramic artists "exist in a world that only looks at other ceramics. Although we are both trained ceramic artists, we pull influence from so many other mediums and disciplines, that it is hard to then show the work only to a crafts based audience. We use craft as a tool and aesthetic, but the work isn't only about that. We are happiest when our works get out of the craft field and into the worlds of art and design, because that is where the ideas are rooted." Katie and Mike have never felt pigeonholed by the Cincinnati arts community. Matt Distel, a curator for The Carnegie in nearby Covington, Kentucky, wrote a grant and exhibition proposal for Future Retrieval to exhibit through FotoFocus, a non-profit celebrating photography through exhibition. Though Davis admits Future Retrieval's finished work is hardly "photographic," the two use photographic processes to achieve their sculptural works. Their large scale project for FotoFocus in 2015, "Grand Theft" used photogrammetry and photography to three-dimensionally scan famous artworks from around the country, which they then translated into porcelain sculptures.

A respect and dedication to every exhibition separates Future Retrieval from other artists. Whether they exhibit in a New York museum or a Cincinnati gallery, Parker and Davis equally value the unique opportunity each venue presents.

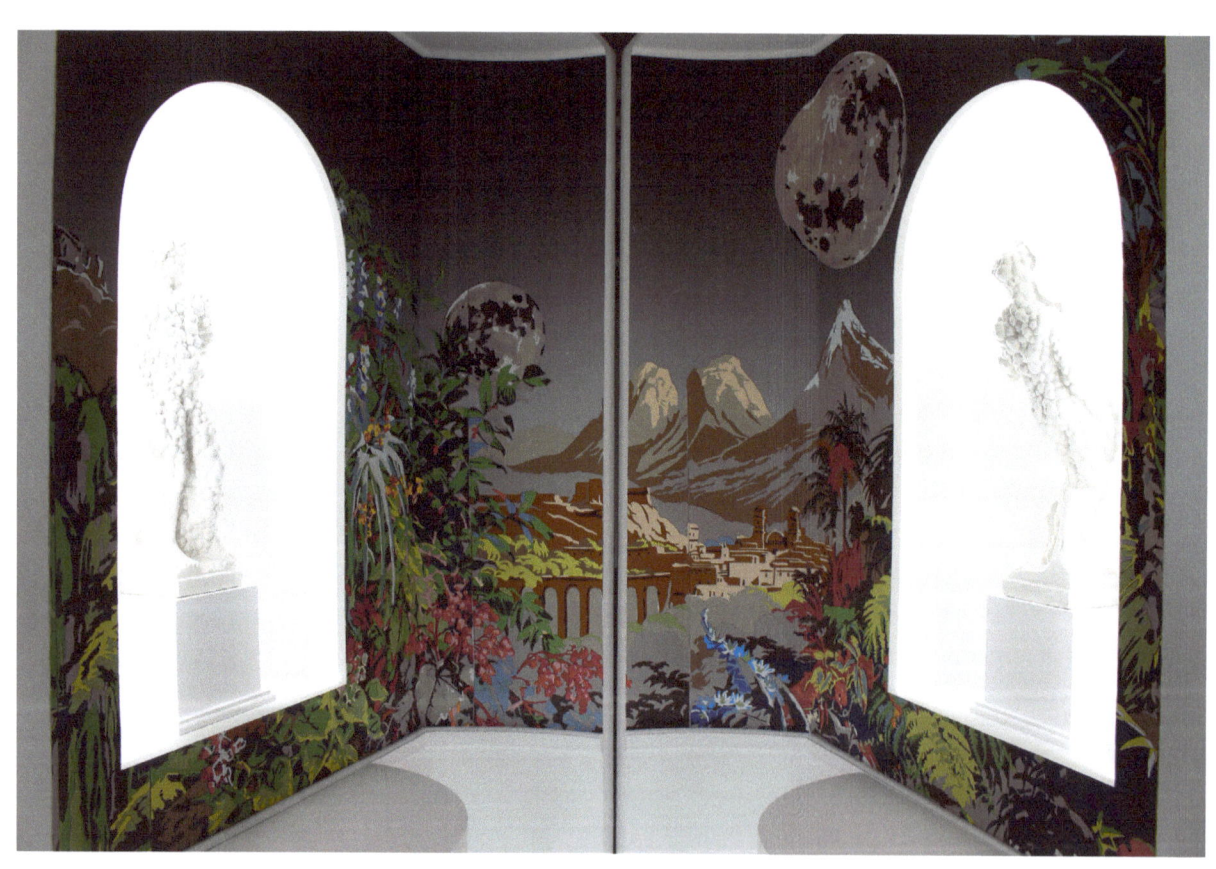

Image of Order, 2014
Installation detail. Cut paper, LEDs, porcelain, plexiglass, wood, formica, 10' x 8' x 2.5'
Made in collaboration with Chris Vorhees

An Interview with Future Retrieval

Emily Moores (EM): Why is it important to you to reuse, borrow or grab historical images?

Future Retrieval (FR): We use historical imagery because it has a story to tell – a start or a beginning to a larger narrative. The objects we use were made at a specific time in a specific place, and it is exciting to use that a point to launch the piece into a contemporary context.

EM: With your name being Future Retrieval, how do you decide what is so good you want it back?

FR: It was sort of a joke – like how do you make something so good you would want to get it back in the future. In the studio we play around with the idea of "getting lucky," – i.e., if you make pieces enough you are bound to create a gem. Those gems can't be made on command, but every once in a while there is a piece that just has something to it, something that can't be nailed down that makes it really special.

EM: How does craft play a role in your work both historically and physically?

FR: Craft plays a role in our work historically because traditionally artists didn't use porcelain… Porcelain is tricky and fussy and hard to work with, so to master the material in a craft sense is the main battle. The European porcelain pieces that influence us – Sevres, Meissen, Nymphenburg – these factories were at the height of craft in their time. We strive to continue that legacy, to make pieces that attempt to control this (for the most part) fluid material.

Physically, we were trained as potters and craft was very important. You can't give someone a cup that has a sharp edge, will ruin a coffee table, will leach coffee through the glaze. Mold making is also super precise, and it doesn't make sense to create a complex 10+ part mold that fits together perfectly and then do a bad job casting or firing it. All our training has instilled a value to time and labor.

EM: While you approach your work with dedication and seriousness, your work has a sense of playfulness. Why is that important to you?

FR: We both have a sense of humor, and it is important to show that. While we are not making work that is a joke – it is a play on the material, the history, our studio practice - we have fun and laugh while we are working, and sometimes the most outrageous idea is the best one. A lot of starts begin with - "wouldn't this be funny," and then it turns into a larger project that actually takes a lot of concentration and problem solving. We do enjoy working and enjoy being together in the studio and want that to come across.

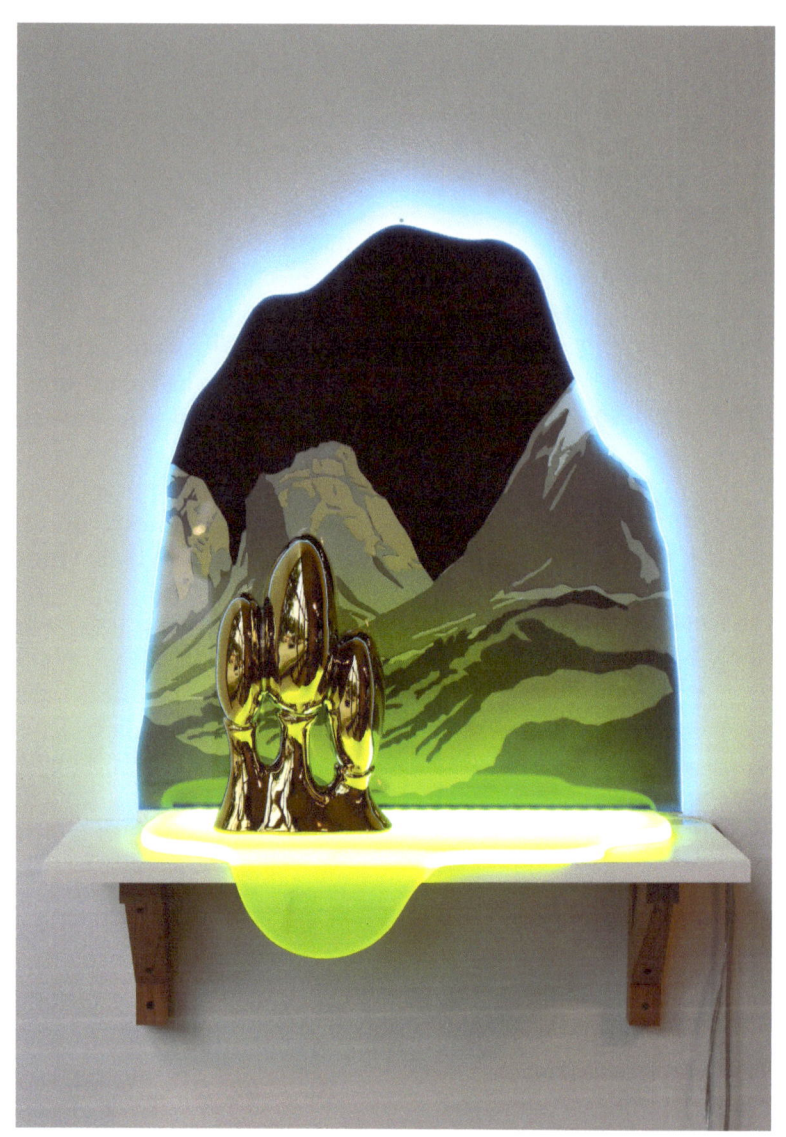

Paradise Valley, 2015
Porcelain, hand cut paper, LEDs, wood, plexiglass, 28" x 26" x 10"
Made in collaboration with Chris Vorhees

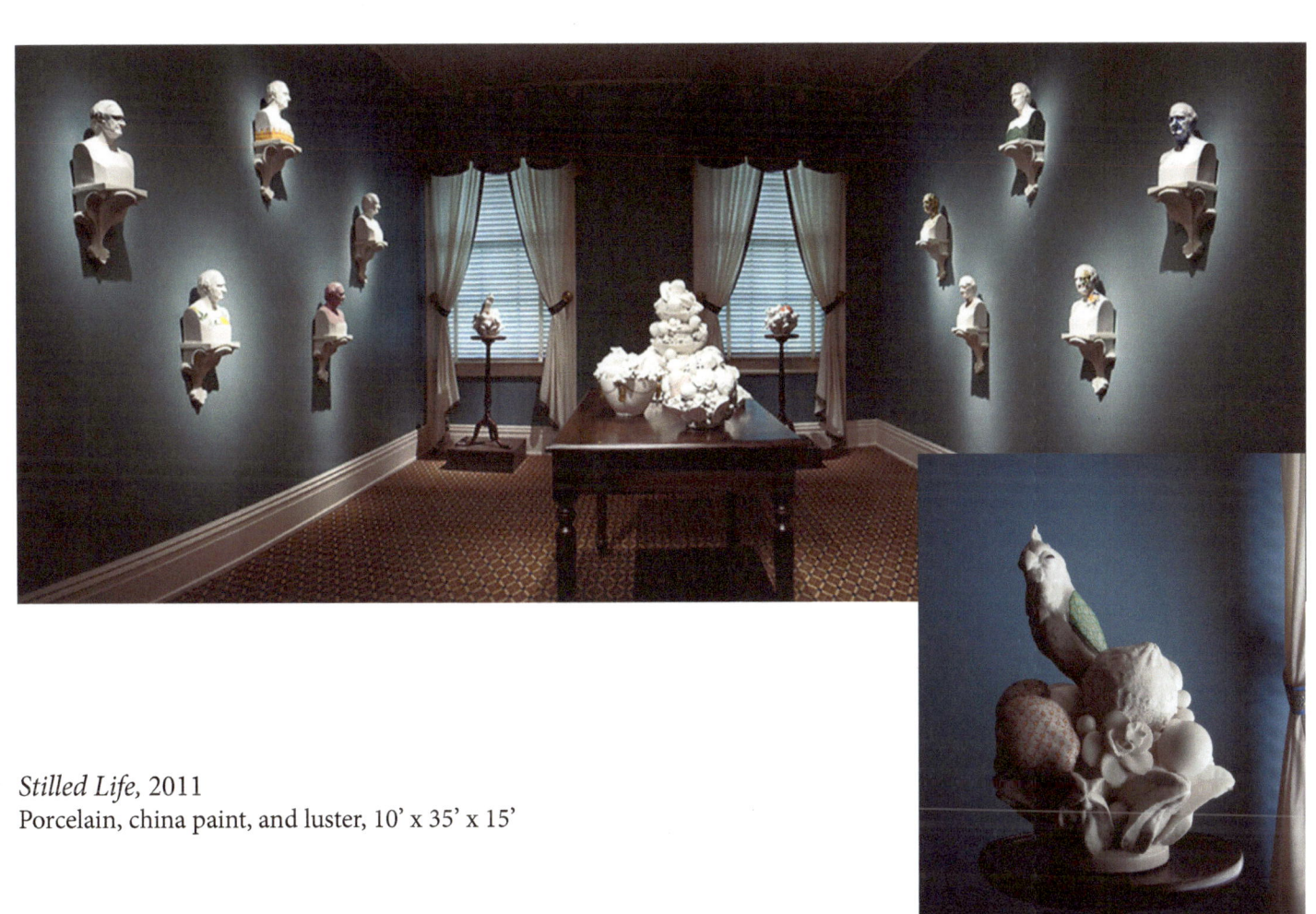

Stilled Life, 2011
Porcelain, china paint, and luster, 10' x 35' x 15'

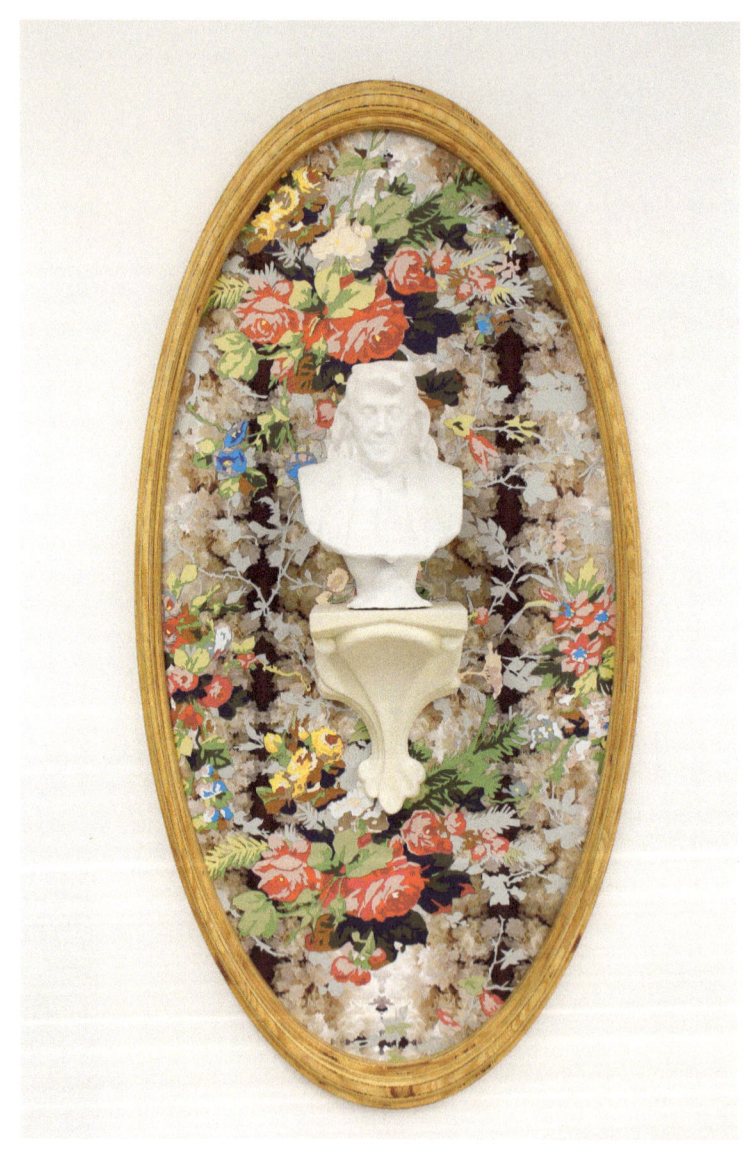

Grand Theft, 2015
Benjamin Franklin, porcelain, hand cut paper, wood, 53" x 26" x 7"

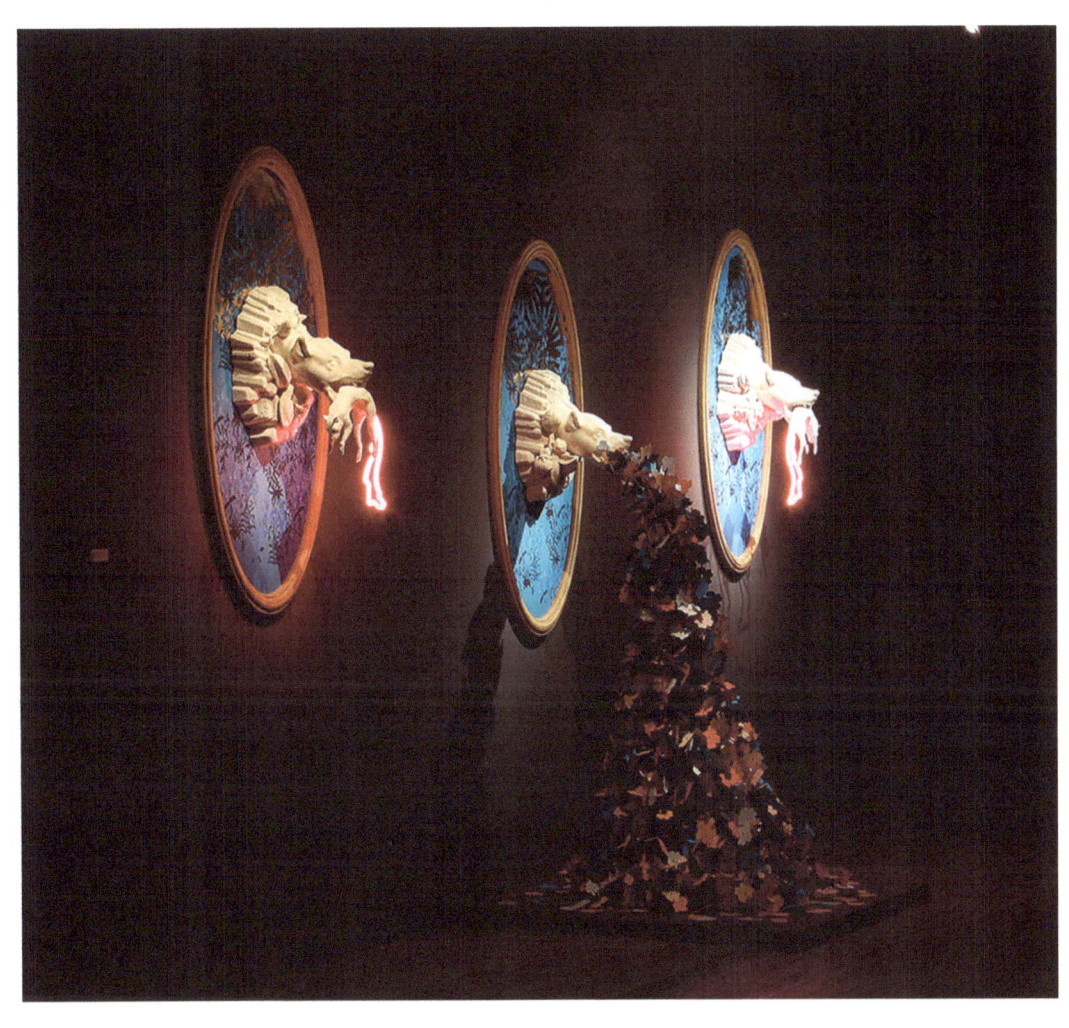

Nymphenburg Still Life, 2012
Porcelain, paper, wood, neon, gold leaf, screenprinted wallpaper, 20' x 7.5' x 3.5'

Published in connection with exhibition:
Cincinnati 5: Artists Impacting the Community

Co-curated by Calcagno Cullen and Emily Moores
Wave Pool Gallery
February 20 – March 26, 2016

Editors: Maria Seda-Reeder, Keith Good, Elizabeth Tussey, Sarah Brinker-Good and Dan Murphy

All images of indivdual works of art are courtesy of the artists.

ISBN 9781523260522
Copyright © 2016 Emily Moores and the artists
ALL RIGHTS RESERVED

Wave Pool Gallery
2940 Colerain Ave.
Cincinnati, Ohio 45225

www.wavepoolgallery.org/

Distribution:
createspace
An Amazon Company
www.createspace.com

www.ingramcontent.com/pod-product-compliance
Lightning Source LLC
Chambersburg PA
CBHW041316180526
45172CB00004B/1116